IMAGES
of America

MAHWAH

Carol Wehran Greene

ARCADIA
PUBLISHING

Published by Arcadia Publishing
Charleston, South Carolina

Printed in the United States of America

Library of Congress Control Number: 2013934061

For all general information, please contact Arcadia Publishing:
Telephone 843-853-2070
Fax 843-853-0044
E-mail sales@arcadiapublishing.com
For customer service and orders:
Toll-Free 1-888-313-2665

Visit us on the Internet at www.arcadiapublishing.com

This book is dedicated to my granddaughter, Clara Isabelle Barrett.

CONTENTS

Acknowledgments 6

Introduction 7

1. The Ancient Ramapo Mountains 9

2. Taking the High Road 19

3. Farm Estates of the 1800s 35

4. Family Farms of the 1900s 49

5. A Station Called Mahwah 61

6. Smokestacks on the Horizon 79

7. Roadside Mahwah 89

8. First Responders Through the Decades 103

9. Unusual Houses 113

ACKNOWLEDGMENTS

Two wonderful people I wish to thank for their help in writing this book are my husband, Dick, and daughter, Lindsey Barrett. Their love and support, passion for research, sense of humor (most of the time), and bright ideas have made this book a memorable family event.

The greatest repository of photographs for writing this book has been the Mahwah Museum. I am amazed by the scope of historical materials gathered under one roof. Thomas Dunn, museum past president, deserves huge credit for his vision in creating state-of-the-art archives, and for constantly sharing his knowledge. The archives include collections of the Havemeyer family (owned by the Mahwah Library), Francis Furman, Isabel Hudson, the Winter family (donated by Angela Karpowich), William Dator, the Mahwah Library, and the Mahwah Historic Preservation Commission, which handled photographs before the museum was founded. I am indebted to Dr. Charles Carreras, current president, and the board for sharing the museum's impressive resources.

I also made individual contacts, with some exciting results. Gene McMannis offered his incomparable postcard collection; Warren Storms and the Heflins shared unique farm photos; Susan Sampson, a childhood friend, sent pictures from California; and Craig Long, Suffern historian, brought rare photos of Mahwah from "across the border." Nancy Garelick and Charles Vanyo of Camp Glen Gray contributed 90-year-old images. Chief James Batelli and the Mahwah Police Department offered photos of road incidents, with incredible backgrounds of 50 years ago. Thomas Dewan, Fire Department historian, and the Fire Companies and Ambulance Corps contributed important photographs. Marcela Perrano provided Stag Hill resources. An old picture surfaced of the Mountain School, saved by William Trusewicz. Mayor William Laforet had rare glass negatives of a local peach-growing family, and historian Marion Brown identified them. Councilman Edward Pehlier obtained a perfect copy of the 1710 Bond map; Jack Shuart, state forest ranger, explained charcoal mounds; and many others provided resources and knowledge.

I thank the Mahwah mayor and council for their support of the Mahwah Museum and this book. I extend my heartfelt thanks to all concerned for making *Mahwah* possible.

—Carol Wehran Greene
Mahwah, New Jersey

INTRODUCTION

Mawewi, meaning "where streams and paths meet," was an ancient place of Indian habitation. Positioned in a river valley at the base of the Ramapo Mountains in New Jersey, it was near the Clove, a natural 14-mile pass through the mountains of New York state. Here, it was destined that paths and people would come together.

The advantages of commerce at such a location attracted Blandina Bayard, a Dutch woman from New York City, to build a trading post in 1700 on the banks of the Ramapo River. More than 300 years ago, this intrepid woman recognized that Mawewi was a geographical and communal crossroads in the wilderness of Bergen County's unsettled frontier. Today, the name of a large hotel and office tower at the site, International Crossroads, attests to the business savvy of Mahwah's first settler.

Indeed, the growth of every settlement or hamlet depended upon its major roads. In Mahwah, the oldest and most important local roads were Ramapo Valley Road, first an Indian footpath, and Island Road, part of the 1600s Post Road from New York City to Albany, designated a King's Highway in 1703. Many of the bends and curves in the earliest roads are the same as they were hundreds of years ago, proving that the best way from here to there often does not change. A century later, in 1806, Franklin Turnpike was chartered. These and subsequent roads opened the way for the growth of the town.

Mahwah has many faces. The Ramapo Mountains are valued for their scenic beauty, forests, streams, and animal habitats. Mountain history includes Native American prehistory, the Revolutionary War, and European and African American settlement history. Although the forges were on the westerly slopes, the iron industry of the 1700s and 1800s affected the mountains of Mahwah by attracting charcoal burners, who produced fuel for the furnaces. Throughout the 1800s, the need to access mountain resources, especially timber, resulted in many well-used mountain logging roads and trails. There are ruins of farms and homesteads where settlers of mixed heritage once lived, seeking land and resources with which to build a future. Ramapough Lenape Nation tribal members, many of whom live in the mountains today, are devoted to preserving their Native American history and culture.

In 1871, a depot was built in Mahwah on the Erie Railroad, and this attracted wealthy entrepreneurs and industrialists from New York City who established "farm estates" in the Ramapo Valley. They could live at their principal residences in the city, and commute to the country, thereby enjoying the benefits of both worlds. The era of farm estates, from the 1860s to the early 1900s, was a resplendent period—Mahwah's page in the history of the Gilded Age. Some of the most extraordinary mansions and buildings from those days survive today and are now Mahwah's historical treasures. Fortunately, institutions like Ramapo College of New Jersey have adaptively used such buildings, preserving them for future generations.

Prior to industrialization, almost everyone was a farmer, either for family sustenance or commercial sales, no matter what other position he might have held. Most families had their own orchard,

kitchen garden, chickens for eggs and meat, a cow for milk, goats, horses for pulling the wagon or plow, oxen, a few crop fields, and so forth. Farmers were resourceful and overcame many hardships. At first, crop and row farmers had a hard time marketing their products because of poor roads and limited markets. The 1871 depot helped the farmers tremendously in reaching new and better markets. Mahwah's agricultural heritage—the "family farm," defined its landscape and the character of much of its population well into the 1900s.

Beginning in the 1700s, water-powered grist- and sawmills with wooden wheels—and, later, turbines—populated every American hamlet in the East that had a stream or river. The demand for sawn wood was insatiable. By the 1900s, the Ramapo Mountains were almost stripped bare of trees, and the timbering had to be stopped. Glen Gray Road and Bear Swamp Road are two of the many old logging roads that still exist in the mountains. The large, water-powered Hopkins & Dickinson Lock Factory (1872–1881) on the Ramapo River employed about 100 to 125 people. The American Brake Shoe Company built a factory in 1902 on the railroad in West Mahwah, and an ethnic community grew up around it. This era of Mahwah's history is important in the American story of industry and labor. The American Brake Shoe factory in Mahwah closed in 1983. Many of the small neighborhood stores, homes, and factory buildings still exist. The last industrial giant to reside in Mahwah was Ford Motor Company, from 1955 to 1980. It was the largest assembly plant in the world at the time. Today, corporate headquarters characterize the town.

Mahwah's history has the added dimension of Suffern and Rockland County history, across the New York–New Jersey state line. Until 1769, the border was in dispute and the two hamlets acted as one. In the late 1800s, before the *Ramsey Journal* was founded in 1892, Rockland County newspapers reported on Mahwah. Suffern families supported churches and causes in Mahwah until the mid-1900s, and vice versa.

Beginning in the 1800s, Mahwah's educational system was characterized by one-room schoolhouses, in which eight grades were taught in one room by one teacher. Commodore Perry School, built in 1906, was the town's first four-room schoolhouse. It is remarkable that four of Mahwah's original seven one-room schoolhouses still exist, adaptively used for other purposes. They are the Masonicus Schoolhouse, built in 1820 and relocated in 1852; the original Darlington Schoolhouse of 1855, now the African Methodist Episcopal Zion Church on Grove Street; the new Darlington Schoolhouse, built in 1891; and the Fardale School, built about 1910. Since then, middle schools and a high school have been built on Ridge Road. Ramapo College of New Jersey was established in 1970, and continues to offer undergraduate and graduate degrees.

Mahwah has been rightly called "Bergen County's Parkland" because there are 9,000 acres of county and state parkland in town. About half of this is mountain land in the Ramapo Valley County Reservation. Other parks comprise the rest, including the Campgaw Mountain Ski Area and Darlington County Park. Since 2002, four major farms in Mahwah, while still privately owned and operated, have been forever restricted to agricultural use by agreement with the county and state. All of these assure that the beautiful landscape of this community will live on.

Mahwah's confluence of farming, grand estates, business, industry, education, housing, and preserved open space make it unique. Each aspect has been significant in shaping Mahwah into the town it is today.

One

THE ANCIENT RAMAPO MOUNTAINS

The Ramapo Mountains in New York and New Jersey are the southwesternmost edge of New York's Hudson Highlands and the easternmost tier of the New Jersey Highlands. The mountains from Maine to Alabama are all part of the Appalachian range, worn down by time to the rounded shapes seen today.

For thousands of years, Native Americans hunted in the Ramapo Mountains, grew crops in the fertile lowlands, and fished in the Ramapo River. European settlement of Mahwah began in 1700 when Blandina Bayard, a Dutch woman from New York City, bought a vast tract of land from the Lenape Indians and established a trading post along the river. Ramapo Valley Road was, even then, a well-worn footpath, and the winding river was a highway for dugout canoes. Several trails converged here and led into New York state.

Romopock, the Indian name for the slanting rock on the face of the mountains, became the name of the region. Today, the Ramapo Mountains are the repository of rich local and regional history unlike that in any other part of Bergen County. There were iron and nickel mines in the mountains, and two centuries of mining, smelting, and forging of iron took place on the westerly slopes. Sooty colliers once populated the mountains, supplying charcoal for the iron industry. Munitions were secretly transported during the Revolutionary War on Cannonball Road, now a hiking and fire service trail. Later, business and industry stimulated logging, and the mountains were almost denuded of trees. Old logging roads are now part of the trail system.

For more than a century, settlers of mixed heritage lived in Green Mountain Valley and Halifax Hollow. The community of Stag Hill is now home to the Ramapough Lenape Nation, organized about 1979, which is dedicated to preserving its Native American culture.

Thousands of acres of mountain land have been preserved by Bergen County, making Mahwah known as "Bergen County's Parkland." Under this mantle of protection, the unique history of the mountains can be enjoyed in perpetuity.

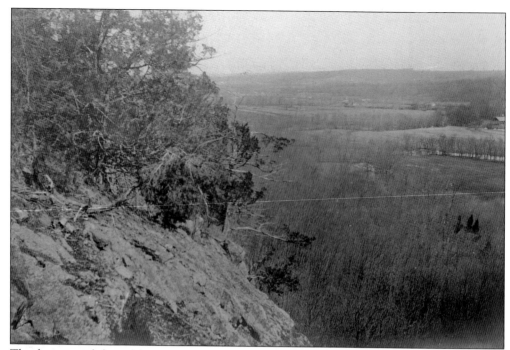

The slanting rock face of the Ramapo Mountains, which gave the region its Native American name of Romopock, was photographed in the 1890s by Henry O. Havemeyer. This view has remained relatively unchanged for tens of thousands of years. (Courtesy of Mahwah Library.)

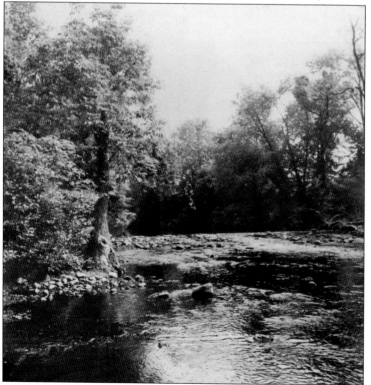

A fish weir, seen here in 1901, extended across the Ramapo River downstream of the confluence of Halifax Brook, close to an Indian encampment. The natives built weirs—rock dams that created deep pools—to trap many kinds of fish. They also used nets, spears, clubs, and their bare hands. This weir was destroyed by recent development. (Courtesy of Mahwah Museum.)

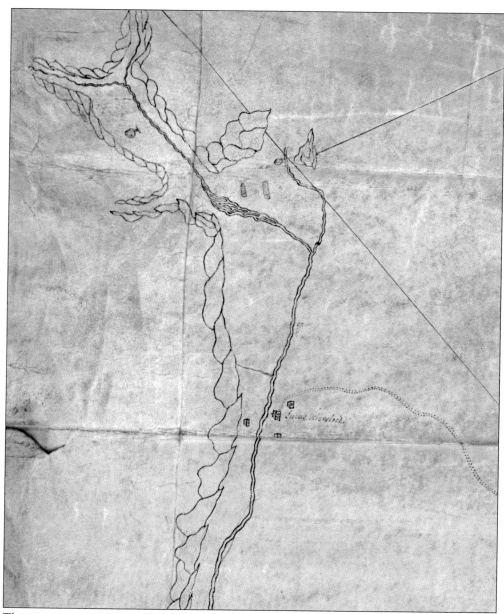

This survey map of the Romopock tract, drawn in 1710 for the New Jersey Proprietors by William Bond, depicts Mahwah's landscape over 300 years ago. It is the first official, professionally drawn map of this area, showing the Ramapo Mountains, the Ramapo River, and the confluence of the Ramapo and Mahwah Rivers. Mawewi, the cleared Indian field, is just north of this convergence. Two Indian longhouses, shaped like caterpillars, are seen on the cleared land. The house (or houses) of Lucas Kierstede, who helped his aunt Blandina Bayard with the trading post, are seen halfway down the map, with a trail leading to the east indicated by dotted lines. Today, the landmark Hopper–Van Horn House marks the location of Kierstede's house, and the International Crossroads Hotel towers over the flats of Mawewi. (Courtesy of Bergen County Map Room.)

According to Lenape legend, Cradle Rock represents a cradle board carried on the back of another. The three small rocks represent the three Ramapough clans: Wolf, Deer, and Turtle, which hold up the larger tribe. The rock formation is in the Ramapo Mountains of Mahwah. (Courtesy of Marcela Perrano.)

Archeological evidence shows that the Darlington rock shelter, in the Ramapo Mountains of Mahwah, was an Indian habitation site. Native Americans occupied these mountains in the Paleo Indian Period (about 10,500 B.C.) and often used natural rock formations such as this one as dwellings. (Courtesy of Edward Lenik.)

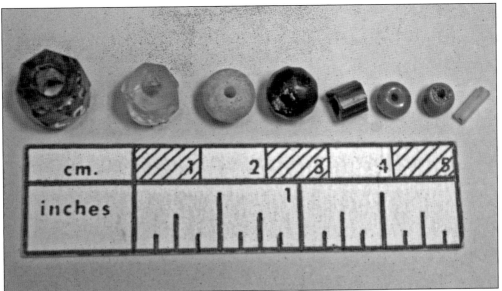

Seen here are eight European glass trade beads, recovered in 1980 near the Hopper–Van Horn House, the site of Blandina Bayard's Indian trading post. Trade beads and wampum, the latter made from conch shells, were units of currency used between frontiersmen and Native inhabitants. There was a wampum factory in nearby Park Ridge. (Courtesy of Nancy Gibbs.)

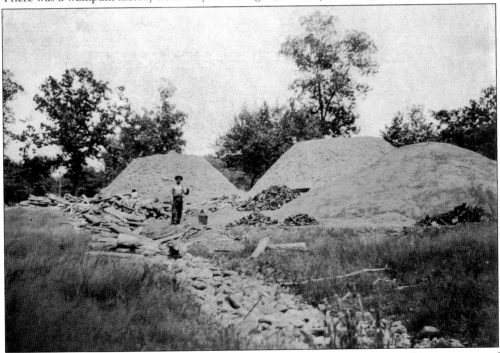

These charcoal mounds, photographed in 1895 by Henry O. Havemeyer in the mountains of Mahwah, consisted of long, hardwood logs vertically stacked in layers and then covered with turf. A fire within cooked slowly to dry and char the wood without burning it. Colliers, or charcoal burners, camped by their fires to keep them smoldering. Charcoal fueled the voracious iron forges, and the consumption of trees was considerable. (Courtesy of Mahwah Library.)

The Jacobus DeGroat House, built around 1902, was located on the property of James DeGroat, the first mountain landowner to get a deed for property on Stag Hill. Log houses built by mountain settlers were common in the Ramapo Mountains. This unsung architectural style is recognized today as one of the truly American types, made possible by abundant forests. (Courtesy of Bergen County Cultural and Historic Affairs.)

Sam Jennings's log cabin in Green Mountain Valley was photographed in 1895 by Henry O. Havemeyer of Mountain Side Farm, where Jennings worked. Havemeyer identified the woman on the porch as "old Mrs. Jennings," with her grandchildren. Today, log houses are considered historically important, but most have disappeared. (Courtesy of Mahwah Library.)

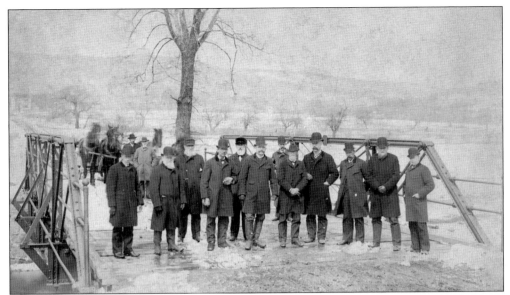

On March 21, 1890, the Bergen County Board of Chosen Freeholders inspected the new, iron Burpo Bridge over the Ramapo River. The record does not say where the bridge was, and it was very possibly swept away by the raging flood of 1903. At least two bridges remained intact: the Cleveland Bridge and the private iron bridge on the Governor Price property. (Courtesy of Mahwah Museum.)

Van Horn Bridge over Ramapo River, Suffern, N. Y.

This postcard from 1917 shows a newly built stone-arch bridge on the Ramapo River, which provided access to the open fields and orchards of Mountain Side Farm and to Green Mountain Valley and the mountains beyond. (Courtesy of Curtis Woodruff.)

15

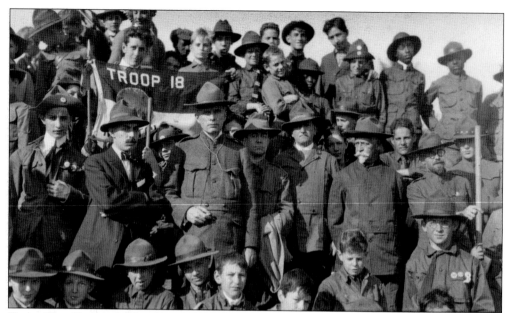

Camp Glen Gray, in Mahwah, was founded by "Uncle" Frank Gray, the tall, clean-shaven man in the Scout uniform and campaign hat to the right of the number 18 on the troop flag. The Montclair Council purchased Camp Glen Gray in 1917. Note that Troop 18 was well integrated a century ago. Scouting in America began in 1910 as part of the international Scout Movement. (Courtesy of Camp Glen Gray.)

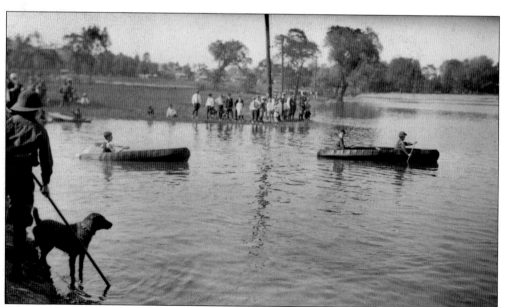

Swimming and canoeing on Boy Scout camp lakes were hallmarks of Scouting. Lake Vreeland, at Camp Glen Gray, was created by damming a mountain stream over a low area with springs. It is still active today. (Courtesy of Camp Glen Gray.)

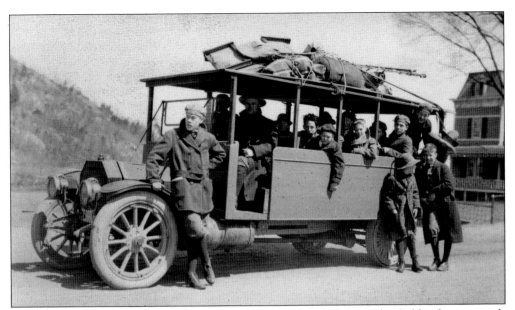

All aboard! This early 1920s, open-air Heyer's autobus is ready to leave the Oakland station with a group of Boy Scouts headed for Camp Glen Gray in Mahwah. The autobus stopped one mile from camp because it could not climb the last, steepest portion of the road leading to the camp. (Courtesy of Camp Glen Gray.)

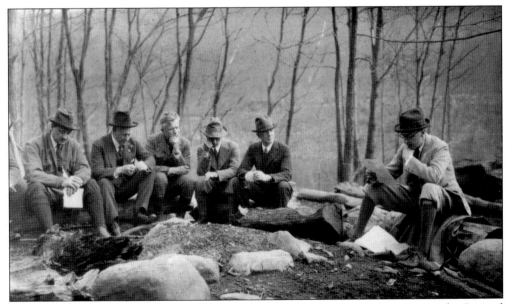

The Montclair Council, which owned Camp Glen Gray, holds a director's meeting at the Council Ring. Frank Gray is third from the left. In 2002, Bergen County acquired the camp to preserve its 750 acres of mountain land, which was threatened by potential development. The camp is now operated by the Friends of Glen Gray. Their motto is "Same Trees, Different Management." (Courtesy of Camp Glen Gray.)

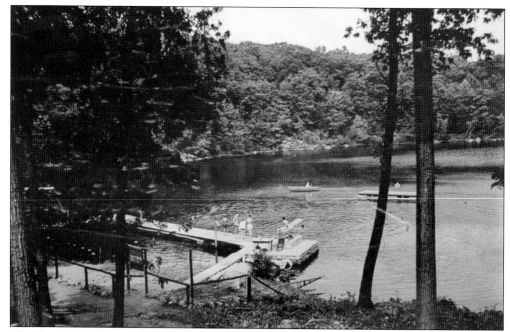

The Yaw Paw Boy Scout Camp Association of Ridgewood, New Jersey, has operated Camp Yaw Paw since about 1922. The camp features Cannonball Lake (seen in this 1940s photograph), a smaller lake, a ranger's cottage, a camp office, a mess hall, and cabins. The Revolutionary War–era Cannonball Road, which skirts the lake, has been a fairly level north-south access road in the Ramapo Mountains since the 1700s. (Courtesy of Gene McMannis.)

Darlington Lakes Country Club, designed and completed in 1955 by conservationist Fred L. Wehran of Mahwah, featured a rustic log pavilion, three lakes, swimming, boating, fishing, picnic groves, and nondiscriminatory membership. It was sold to Bergen County in 1965 and renamed Darlington County Park. Today, it is one of the largest public swimming lakes in Bergen County. (Courtesy of Mahwah Library.)

Two

TAKING THE HIGH ROAD

To the Bergen County surveyors laying out roads in the early 1700s, the "high road" meant the highest elevation and the best way around swamps, ditches, hillsides, steep climbs, and other obstacles. For instance, a section of Island Road surveyed in 1744 "begins by the Meeting house on the east side of the Swamp upon the good Ground for a High Way."

Bergen County surveyors were constantly challenged to choose good ground, as the region was full of swamps. Island Road was part of a 1703 King's Highway from Hackensack, and also part of the Albany Post Road–West Route from New York City to Albany. When Franklin Turnpike was chartered in 1806, traffic shifted from circuitous Island Road to this new, seven-mile-long road, which was straight, level, and solidly built.

Toll roads such as Franklin Turnpike attracted investors seeking to profit by improving America's primitive roads. The turnpike era lasted from 1801 until the coming of the railroad in the 1850s, which put not only turnpikes, but also many stage lines and wayside inns, out of business. Nonetheless, some of the best roads in the East today were originally built as turnpikes or toll roads. Franklin Turnpike is still one of the straightest roads in Bergen County.

Road modernization began in Mahwah in 1890 when Theodore Havemeyer privately macadamized a portion of Ramapo Valley Road. The Hohokus Township Committee macadamized Franklin Turnpike in 1897 and finished to the state line in 1908. By the 1930s, most important roads had been improved. As population increased, so did traffic and the number and quality of roads.

The George Washington Bridge, completed in 1931, was served in New Jersey by newly built Route 4. Route 2 (now Route 17) in Mahwah was opened in 1932. New York's Thomas E. Dewey Thruway, sweeping close to Mahwah, was completed in 1956, and Interstate 287 in New Jersey finally reached the New York state line in 1993.

Good roads, speed, and ease of travel made faraway places seem closer, which broadened choices for families on where they could live.

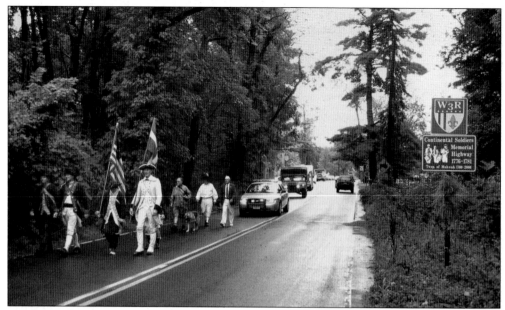

In August 2006, America's March to Yorktown reenactors marked the 225th anniversary of the Washington-Rochambeau campaign of 1781 by marching from Rhode Island to Yorktown, Virginia. The original route followed Ramapo Valley Road; in just one day in 1781, over 7,000 troops, as well as wagons, oxen, horses, and cannons, passed through Mahwah on this road. (Courtesy of Alex Rainer.)

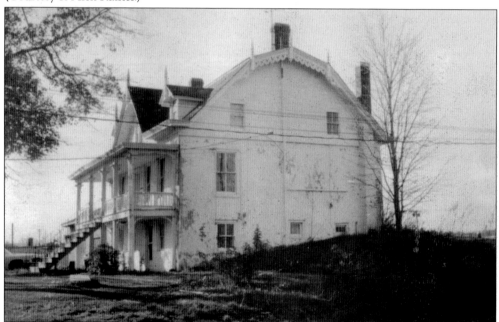

Before Franklin Turnpike was chartered in 1806, this building on Island Road was reportedly a stagecoach inn. Here, drivers delivered US mail and refreshed their horses, while passengers had a meal and stayed overnight. A long hall on the second floor with a balcony outside was used for socializing. This architecture was typical of inns. Amid great protest, the inn was eventually torn down and replaced with a Burger King. (Courtesy of Mahwah Museum.)

East side of the River.					
King's Bridge		13	Hackensack	9	12
Yonkers	4	17	New Prospect	10	22
Dobb's Ferry	6	23	New-York State Line	7	29
Tarrytown	7	30	Ramapo (Pierson's Factory)	3	32
Sing-Sing	5	35	The Clove	18	50
Peekskill	11	46	Canterbury	10	60
Fishkill	22	68	Newburgh	4	64
Poughkeepsie	17	85	Milton (half way)	11	75
Rhinebeck	15	100	Pelham	11	86
Red Hook	7	107	Walkill River	7	93
Clermont	8	115	Kingston	3	96
Hudson	17	132	Ulster Village	10	106
Kinderhook	15	147	Catskill	12	118
Albany	13	160	Athens	5	123
West side.			Coxsackie	7	130
Ferry from Barclay-street to			New-Baltimore	6	136
Hoboken	1½		Coeymans	2	138
Weehawk Hill	1½	3	Albany	13	151

1*

This rare 1836 copy of *William's New York Annual Register* features the mail route from New York to Albany via the east side of the river, and the lesser-known west side route from the Hoboken Ferry to New Prospect (Ho-Ho-Kus/Waldwick), then to the New York state line (Mahwah), then up the Hudson River to Albany, a grand total of 151 miles. (Courtesy of the author.)

This section of I.H. Eddy's 1812 *Map of the Country Thirty Miles Round the City of New York* shows the northern half of Franklin Turnpike from the state line to the tollgate, "Toll G," in present-day Allendale. Here, the turnpike is called the New Prospect & Goshen Turnpike instead of Franklin Turnpike, since the connecting Orange Turnpike leads to Goshen, New York. (Courtesy of the author.)

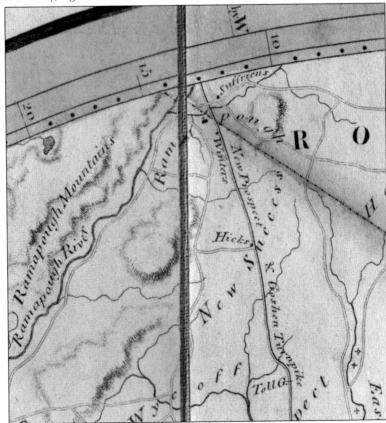

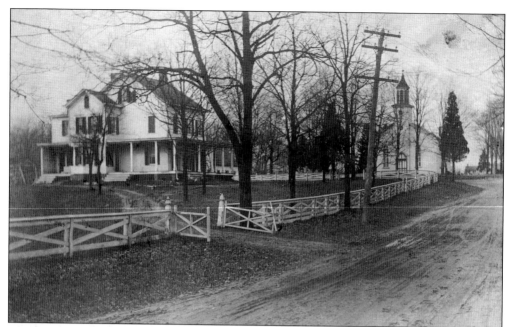

The parsonage of the Ramapo Reformed Church looks inviting in this 1907 scene, with its white wooden gate opening onto Island Road. Recent wagon tracks, hoofprints, and footprints mark the daily use of the dirt road. The church is in the background. (Courtesy of Ramapo Reformed Church.)

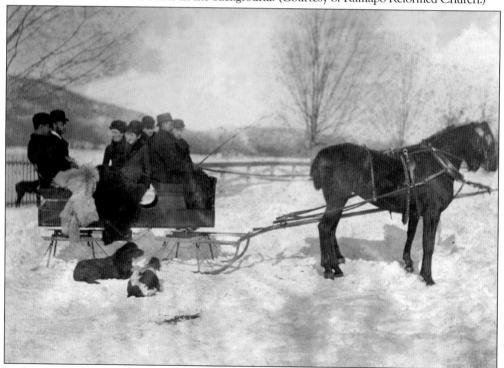

A sleigh ride at Theodore Havemeyer's Mountain Side Farm, in the Ramapo Valley, was a family outing, even for the dogs. Cleated horseshoes and even strap-on hoof chains were used to improve the horses' footing in ice and snow. (Courtesy of Mahwah Library.)

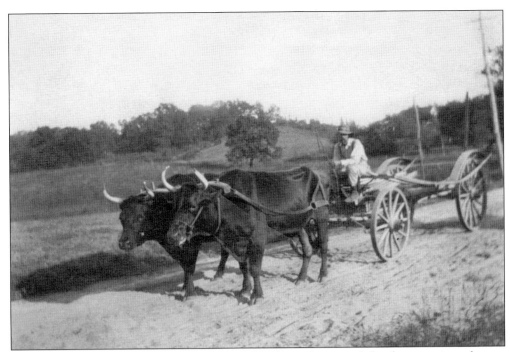

Albert Winter's team of powerful oxen was a familiar sight around the depot section of town, where he lived and worked, and at Mahwin Farms, his stock farm and dairy operation, which ran from Island Road to Ridge Road. (Courtesy of Mahwah Museum.)

Hauling heavy loads was a necessary task for farmers in the early 1900s. This tree trunk is being taken to the neighborhood sawmill in the Fardale section of Mahwah. Note the "parking brakes" in front of the wheels of the wagon. The Ackerman House, in the background, still stands at the corner of Forest and Wyckoff Avenues. (Courtesy of Thomas and Jo Heflin.)

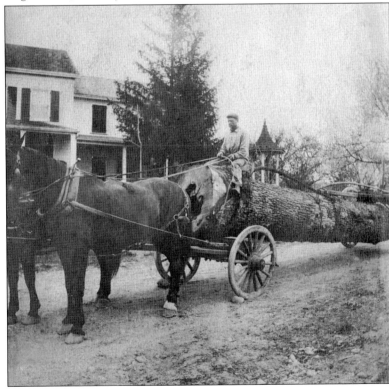

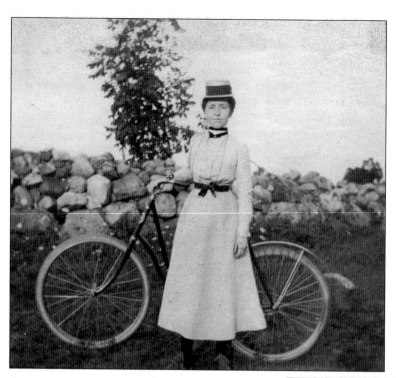

In the 1890s, Susan B. Anthony said, "The bicycle has done more for the emancipation of women than anything else in the world." Suddenly, women could go anywhere without chaperones. Annie Carpenter Winter (1880–1961), who grew up in the Ramapo Valley, obviously agreed. Ramapo Valley Road had been macadamized in 1890 and was a popular bicycle route. (Courtesy of Mahwah Museum.)

Theodore Havemeyer's roadwork was great news for cyclists, especially the local Ramapo Valley Wheelmen, a chapter of the League of American Wheelmen. Henry Benedict's 1890 Cyclists Road Map of New Jersey (below and right) shows the entire stretch from Darlington to the Ramapo Reformed Church as a level-grade macadamized road in fine condition. (Both courtesy of the author.)

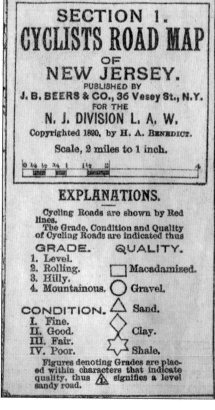

SECTION 1.
CYCLISTS ROAD MAP
OF
NEW JERSEY.
PUBLISHED BY
J. B. BEERS & CO., 36 Vesey St., N.Y.
FOR THE
N. J. DIVISION L. A. W.
Copyrighted 1890, by H. A. Benedict.

Scale, 2 miles to 1 inch.

EXPLANATIONS.

Cycling Roads are shown by Red lines.
The Grade, Condition and Quality of Cycling Roads are indicated thus

GRADE.	QUALITY.
1. Level.	
2. Rolling.	▢ Macadamized.
3. Hilly.	
4. Mountainous.	◯ Gravel.
	△ Sand.
CONDITION.	
I. Fine.	◇ Clay.
II. Good.	
III. Fair.	✩ Shale.
IV. Poor.	

Figures denoting Grades are placed within characters that indicate quality, thus ▲ signifies a level sandy road.

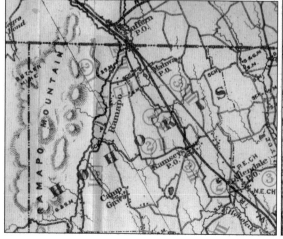

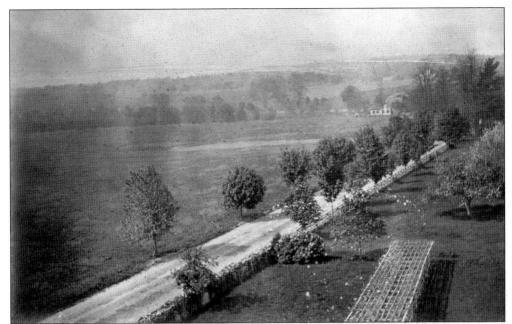

In 1895, the Havemeyers could see their newly macadamized Ramapo Valley Road from the belvedere (rooftop lookout tower) of their mansion. These road improvements were ahead of the times by at least a decade. A pergola in the garden runs parallel to the road, and the stone walls lining the road were built by skilled European immigrants hired by Havemeyer. (Courtesy of Mahwah Library.)

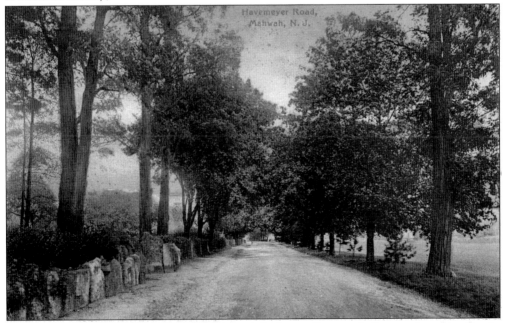

Havemeyer Boulevard showed the full potential of macadam roads for travel on bicycles, in carriages, and, of upcoming importance in the early 1900s, automobiles. The standing rock slices on the left are unique to Havemeyer's stonecutters. Set into the ground, they formed an imposing stone fence at the residence. (Courtesy of Gene McMannis.)

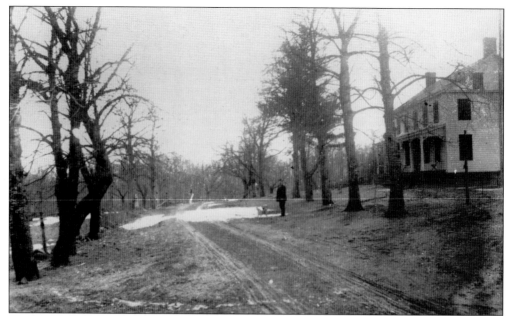

The Retaliate family lived in this commodious house on Campgaw Road, seen here around 1910. Typical dirt roads like Campgaw Road were muddy in spring, dusty in summer, and prone to collecting water, as this photograph shows. Dirt roads were most passable in winter, when horse-drawn sleighs were driven on top of the snow and ice. The Retaliates were peach and apple growers. (Courtesy of William Laforet.)

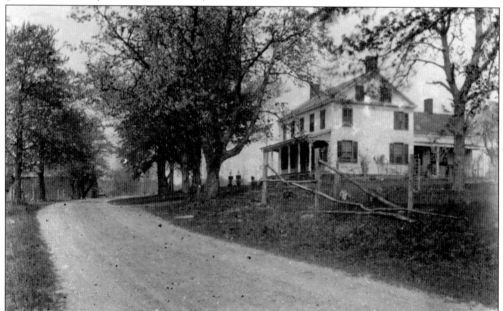

The difference in the appearance of the Retaliate property after Campgaw Road was surfaced in crushed stone is remarkable. Local mailmen surely must have appreciated the road improvements. The Campgaw section of Mahwah received mail by rural free delivery, established in 1896, and, over the years, from various post offices including Franklin Lakes, Ramsey, and Mahwah. (Courtesy of William Laforet.)

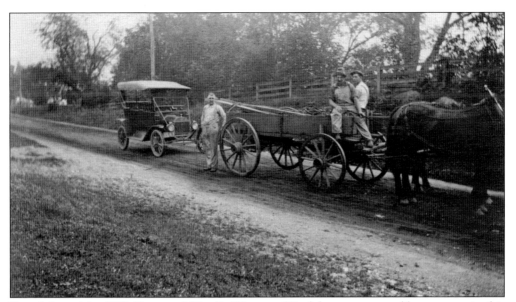

From left to right, Will, Papa, and Charlie Winters of Fardale were captured by a camera in this rare blending of past and present when their two vehicles, a 1912 Ford with a 1915 license plate and a horse-drawn wagon, were parked together on a local dirt road. By the mid-1920s, almost everyone had a car, and interesting encounters like this no longer occurred. (Courtesy of Thomas and Jo Heflin.)

The Retaliate family of Campgaw Road appears to be dressed in their Sunday best in this photograph. The buggy horse is groomed and shining, the leather harness is polished, and the fringe is on the surrey. (Courtesy of William Laforet.)

Cragmere Park, created as a planned development of approximately 150 acres in 1908, offered beautiful vistas of the Ramapo Mountains from land that was once part of the Ezra Miller estate. This view shows Miller Road around 1910. Leo Bugg, a Cragmere Park agent, advertised "tarviated" roads, a form of macadam stabilization. (Courtesy of Mary Ellen Pryde Abrams.)

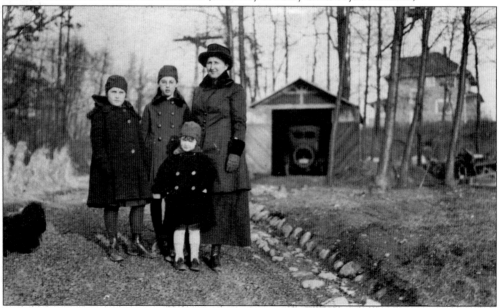

Mary Smith and her three daughters, from left to right, Margaret, Katherine, and Mary, pose for a photograph on Miller Road in Cragmere Park. The back of their car can be seen in the garage behind them. (Courtesy of Mary Ellen Pryde Abrams.)

VIEW FROM MALCOLM ROAD, CRAGMERE, Mahwah, N. J.

Many trees were harvested on the hillside to create the estate Oweno, and, later, to develop Cragmere Park. The poet Joyce Kilmer wrote the poem "Trees" at his home in Cragmere Park; he may have felt that the poem would help give meaning to preserving trees. Today, the hillside is resplendent with mature trees and the regrowth of the past century. (Courtesy of Gene McMannis.)

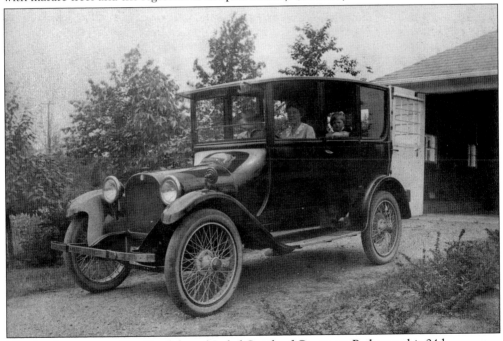

The family car owned by Havilah and Isabel Smith of Cragmere Park was this 24-horsepower 1918 Dodge sedan. Seen here at the wheel is Isabel, a licensed driver, with young Isabel in the backseat. Note the small size of the garage, barely large enough for this narrow car. The Dodge dealer was in Suffern. (Courtesy of Mahwah Museum.)

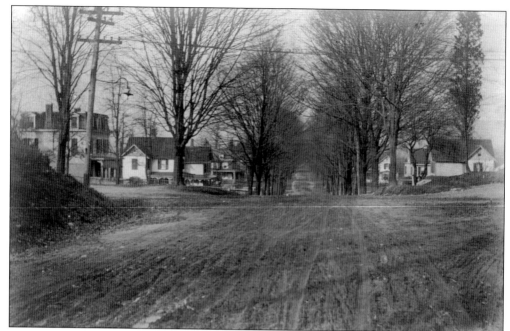

The intersection of Franklin Turnpike and Miller Road, at the depot section of Mahwah, is seen here before Franklin Turnpike was macadamized in 1908. Note how bare the center of town was at the time. The mound of dirt on the left was graded away for Depot Park, built in 1913. All of the houses have since been removed for commercial development. (Courtesy of Mahwah Museum.)

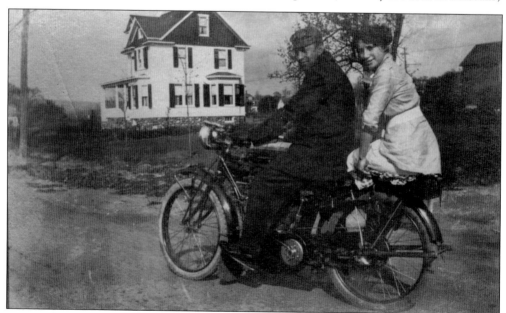

By 1912, with a steady stream of automobiles traveling on Franklin Turnpike, the appearance of a motorcyclist with his girlfriend on the backseat would only be mildly surprising. Motorcycling was popular as both a sport and as an economical way to travel, such as going to work. Brands like Harley-Davidson, Indian, Henderson, and Excelsior were household names. (Courtesy of Mahwah Museum.)

The imposing and expanding American Brake Shoe Company factory is seen here in the distance from the corner of Island and Ramapo Valley Roads in West Mahwah. A mid-1930s car is parked along the road. Not seen on the left side of the street going uphill is Janek's Market. Warhol's Bar (now Mahwah Bar and Grill) is across the street from Janek's, behind the photographer. (Courtesy of Mahwah Police Department.)

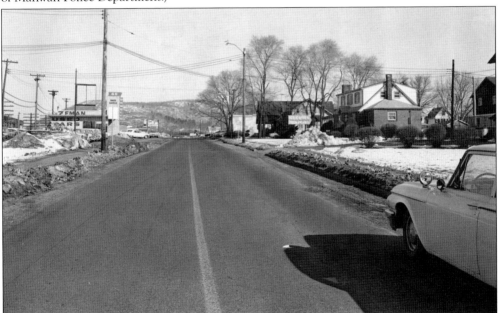

Point of the Mountains, the tip of the Ramapo Mountain range in Suffern, is always a part of the view at this end of town from the northbound lane of Franklin Turnpike. This 1963 scene includes an icehouse on the right and the Zeman Motors Rambler dealership on the left. Unseen behind the camera are the American Brake Shoe buildings and the Erie Railroad. (Courtesy of Mahwah Police Department.)

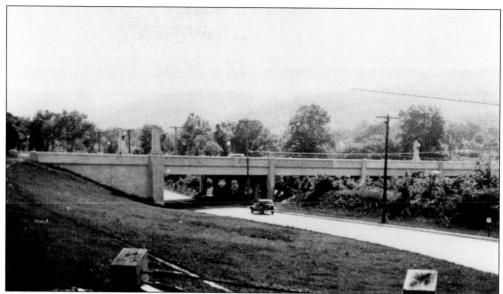

This photograph shows a 1930s car in the southbound lane of Route 202 along the Ramapo River, about to pass under the impressive new three-lane, concrete Route 2 (now Route 17) bridge. The bridge spanned above Route 202 and the river. Portions of the original concrete railing and light towers can still be seen on the southbound lanes. This concrete section of Route 202 still exists over 75 years later. (Courtesy of Mahwah Museum.)

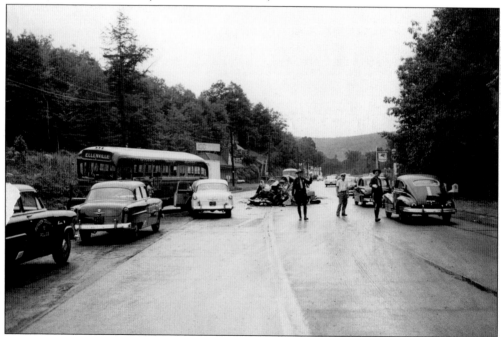

Route 17 was originally three lanes wide, with the middle lane for passing or turning. There were intersections but no streetlights. The accident rate was so alarming that the road was referred to as "Butcher Boulevard." Seen here in 1954 are the tangled remains of a car and an inter-city bus in front of the 400 Club, one of several bars on Route 17 southbound. (Courtesy of Mahwah Police Department.)

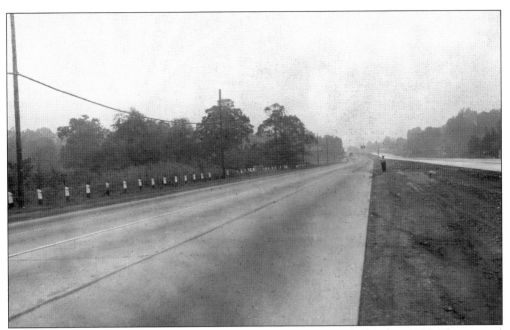

In response to the traffic tragedies on Route 17, the highway was dualized in 1956. The original three lanes are on the left, and the new northbound lanes are on the right. The former Sunset Lake Resort (originally Wanamaker's millpond), just off to the right of the new lanes, was filled in by the road widening and developed for commercial uses. (Courtesy of Mahwah Police Department.)

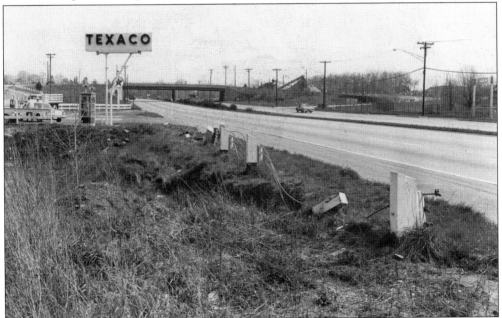

Another Mahwah Police Department photograph shows Route 17 after it was dualized in 1956. It is remarkably undeveloped compared to today. This scene looks southwest at the MacArthur Boulevard/North Central Avenue/Island Road overpass. Note the McKee Sand & Gravel pyramid in the center-right background. The wood and cable guard fence had been knocked down, in spite of there being four lanes. (Courtesy of Mahwah Police Department.)

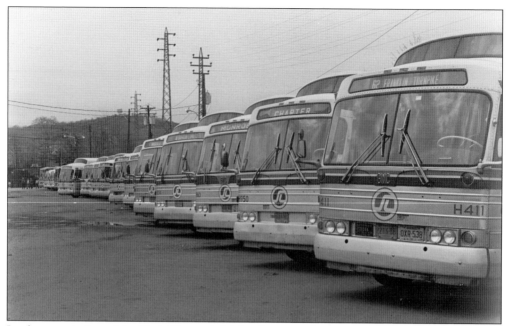

Its close proximity to New York City made Mahwah a prime location for commuters, and bus lines ran frequently to accommodate them. Hudson Transit Lines/Short Line had its largest garage facility on Franklin Turnpike in Mahwah. This lineup of Short Line buses, seen during the drivers' strike in the spring and summer of 1981, is impressive. (Courtesy of Mahwah Museum.)

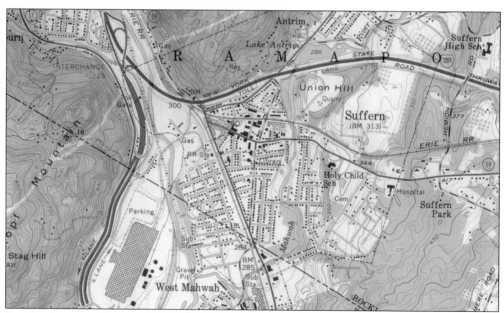

In order for any road, ancient or modern, to make an east-west crossing of the Ramapo Mountains in New York, it first had to be routed south, around the Point of the Mountains in Suffern (under the "R-A-M" of Ramapo on the map). This brought the most important roads of the region through, or close to, Mahwah, making the area a crossroads from its earliest settlement to modern times. (Courtesy of the author.)

Three

FARM ESTATES
OF THE 1800s

As early as 1815, wealthy entrepreneurs discovered that the Ramapo Valley in Mahwah was a beautiful place to live. The families of Henry Hagerman, his son Andrew Hagerman, Abraham Bockee, Rev. John Sheffield, Hugh Maxwell, John Petry, and former New Jersey governor Rodman Price established farm estates on Ramapo Valley Road. The valley took on added appeal in 1871 when Mahwah's Erie depot was built. After that, prominent businessmen and industrialists with principal residences in New York City could easily commute to their country estates in Mahwah.

In 1872, Alfred B. Darling, the owner and manager of the Fifth Avenue Hotel in New York City, established Valley Stock Farm in the Ramapo Valley. Col. Ezra Miller, the inventor of a railroad coupling patented in the 1860s, built his estate, Oweno, in 1873 on the hillside east of the depot. Theodore Havemeyer, a partner in the Havemeyer & Elder Sugar Refining Company, then the largest such company in the world, came to the Ramapo Valley in 1878 and began building Mountain Side Farm. Other outstanding entrepreneurs would follow, but Darling, Miller, and Havemeyer, Mahwah's most famous commuters, were the granddaddies of them all.

Families in this social stratum had other income to develop and support their farms. The farm estates were larger than life, just like their owners. Here, as everywhere in those times, the race was on to breed the best cows that produced the most butter, to breed and race the finest horses, and to build the best barns and have the cleanest dairies. Darling's prize Jersey cow, Eurotas, produced a record 778 pounds of butter in 11 months and five days, making her a nationwide celebrity. Darling's cows were among the highest-priced Jerseys in the world. Havemeyer's herd of Jersey cows, worth $150,000 in 1933, yielded 6,450 pounds of milk per cow per year—twice the national average. Undeniably, these men advanced the frontiers of agriculture and animal husbandry.

It was a spectacular passing parade, and many of the splendid buildings produced during this era still grace the valley today.

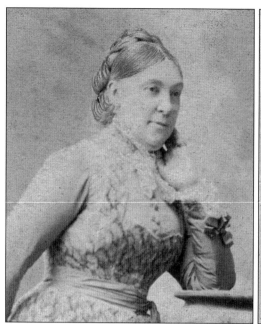

Alfred B. Darling (above, right), the owner of the prestigious Fifth Avenue Hotel in New York City, came to the Ramapo Valley in 1872 to breed fine cattle and trotting horses. His trotter Axworthy was one of the greatest sires in the country. Darling often showed him off on the half-mile racetrack on his property. He took pride in his dairy products, shipping daily from Ramsey's station to the Fifth Avenue Hotel. The farm neighborhood grew into the hamlet of Darlington. The Darlings had no children, but Lydia Darling (above, left) was fond of Annie Carpenter, whose father, Edwin F. Carpenter, was the superintendent of Valley Farm. Annie Carpenter Winter (1880–1961) became prominent in Mahwah history. The beautiful wood-frame, Victorian-style Darling mansion (below) stood on land adjacent to what is now the parking lot of the Bergen County Ramapo Reservation. (All courtesy of Mahwah Museum.)

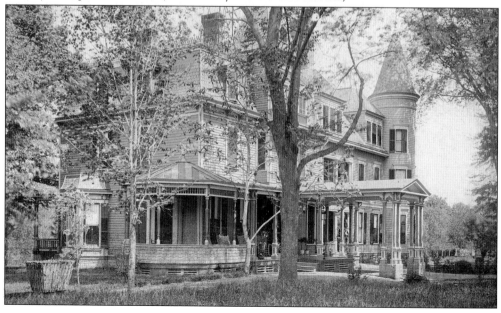

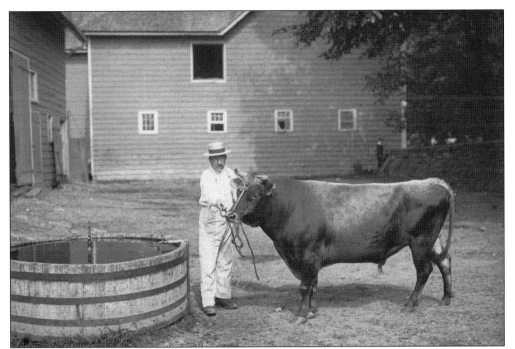

In 1873, Alfred Darling imported two fine Jersey cows from the Isle of Jersey in the English Channel and became a pioneer of the breed in the United States. His Valley Farm Jersey bull, the Duke of Darlington, was world famous. The bull in this photograph might be the Duke, but there is no proof. Several lines of purebred Jersey herds trace their lineage to this bloodline. (Courtesy of Mahwah Museum.)

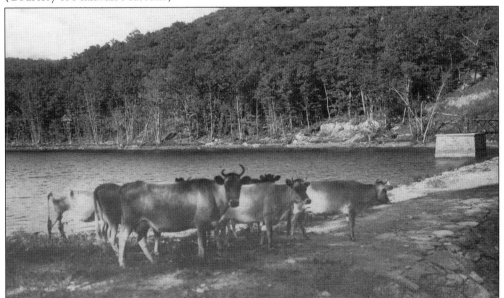

Jersey cows, considered the most outstanding producers of high-butterfat milk, had ample pastureland, the best feed, and clean barns at Valley Farm. As seen in this photograph, they also had fresh mountain water from this reservoir at the base of Campgaw Mountain. (Courtesy of Mahwah Museum.)

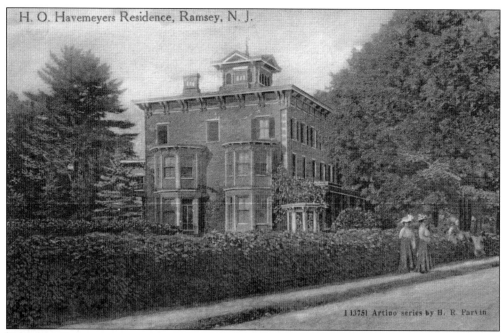

Theodore Havemeyer, a sugar importer and refiner, and his wife, Emilie, established Mountain Side Farm in 1878. In the 1890s, they remodeled their home, originally the 1850s Hagerman house, into a Victorian mansion. In the process, the attached Andrew Hopper House, which was built before the Revolutionary War and had served as George Washington's headquarters, was taken down. The mansion is now the home of the president of Ramapo College. (Courtesy of Mahwah Museum.)

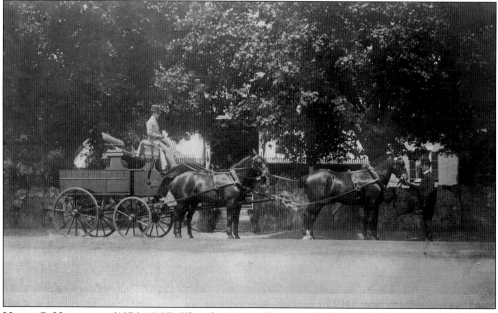

Henry O. Havemeyer (1876–1965), Theodore's son, photographed many local scenes in the 1890s. This photograph is captioned, "Father's Four-in-Hand." The Havemeyers were prominent members of the Tuxedo Club, in Tuxedo Park, New York, and were driven there often in this comfortable, sturdy carriage. (Courtesy of Mahwah Library.)

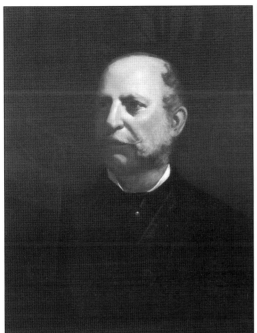

Theodore A. Havemeyer (1839–1897) and his wife, Emilie deLoosey Havemeyer (1840–1914), had nine children. In addition to their residence at Mountain Side Farm in Hohokus Township (Mahwah), they had a large townhouse in New York City and a mansion in Newport, Rhode Island. (Both courtesy of Mahwah Library.)

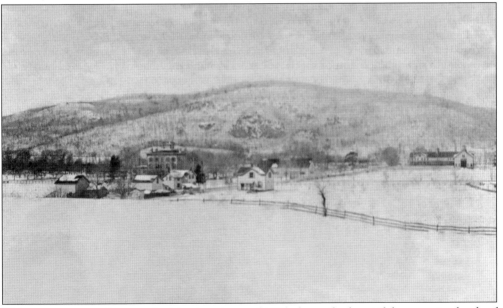

This snowy scene, photographed in the winter of 1895, shows the beautiful, expansive lands of Mountain Side Farm, situated at the base of the Ramapo Mountains along the Ramapo River. The mountainous land provided not only views for those who lived there but also private woodlots that yielded timber used by local sawyers and carpenters as the estate farm was developed and expanded. (Courtesy of Mahwah Library.)

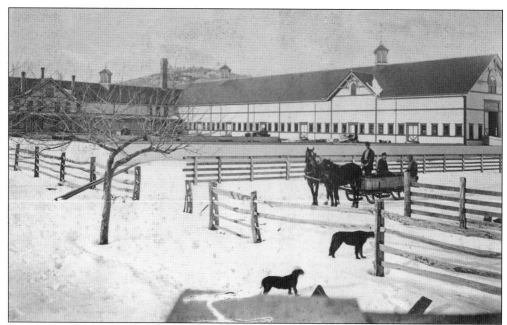

The cow barn, designed by Havemeyer's Newport, Rhode Island, architect, Dudley Newton, held 500 Jersey cows. It had a silo for 600 tons of fodder and a dairy for bottling milk, pressing cheese, and producing butter. There was a separate bull barn, horse stable, piggery, chicken house, and sheep fold. The public was welcome to visit the buildings and watch the milking at Mountain Side Farm. (Courtesy of Mahwah Library.)

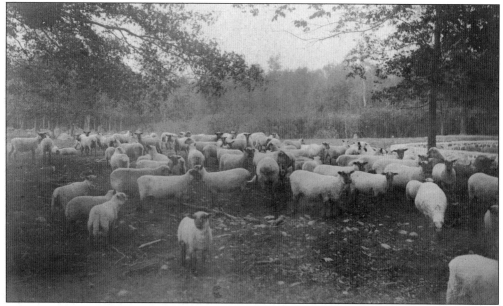

At Mountain Side Farm, there were Southdown sheep, horses, Yorkshire hogs, light Brahma chickens, laying fowl, ducks, and prize fantail pigeons. A deer preserve occupied 600 acres, and the pheasantry, containing 8,000 birds and hares, was the largest in the country. As an example of the work required to feed all of these creatures, there were often 10 teams of horses at once tending the fields of crops. (Courtesy of Mahwah Library.)

Theodore Havemeyer's daughter Nathalie and her husband, John Mayer, the manager of Mountain Side Farm, married and had four children. In 1900, Nathalie died tragically at only 36 years of age. (Courtesy of Mahwah Library.)

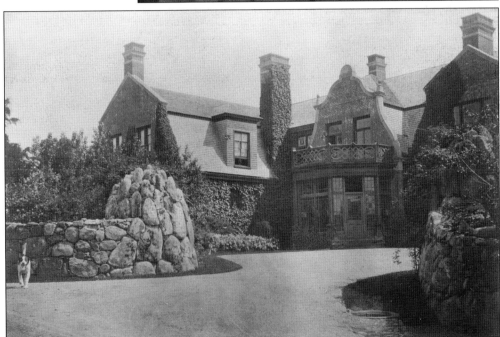

The Mayers lived in this beautiful mansion at Mountain Side Farm, given to them as a wedding gift by Nathalie's parents, the Havemeyers. The mansion, built between 1887 and 1890, later became the home of Stephen Birch Sr. and his wife, son, and daughter. Birch eventually added a wing, which includes the York Room. The house is now the administration building at Ramapo College. (Courtesy of Mahwah Library.)

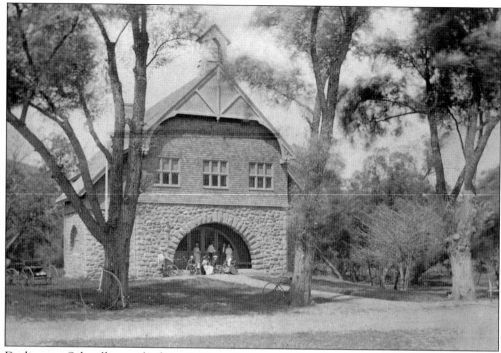

Darlington Schoolhouse, built in 1891 on Ramapo Valley Road, was financed by Theodore Havemeyer in response to the need for a better neighborhood schoolhouse. It is a fine example of Gilded Age architecture and was designed by Havemeyer's architect, Dudley Newton. This scene shows Rosencrantz family members, of The Hermitage in Ho-Ho-Kus, visiting the schoolhouse on a bicycle tour. (Courtesy of The Hermitage.)

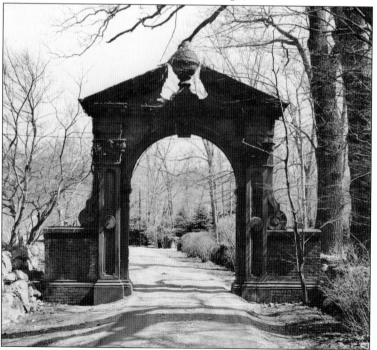

This arch once stood on the grounds of the Havemeyers' Madison Avenue mansion in New York City. It was moved to Mountain Side Farm when the Mayer mansion was built. Today, the property belongs to Ramapo College. Just as one passes under the arch, the property has passed from one purpose and era of history to another. The arch is now the college's logo, appearing on its signs. (Courtesy of Mahwah Museum.)

In 1873, Col. Ezra Miller, an engineer and inventor, built Oweno, a farm estate on the hillside east of Mahwah's depot with a commanding view of the Ramapo Mountains. He is seen here talking with his granddaughter in the opulent drawing room. The *Bergen Democrat* described Oweno as "one of the most beautiful rural homes in the United States." (Courtesy of Mahwah Museum.)

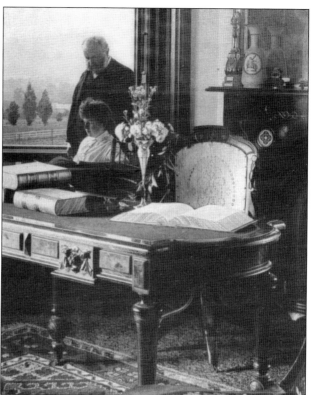

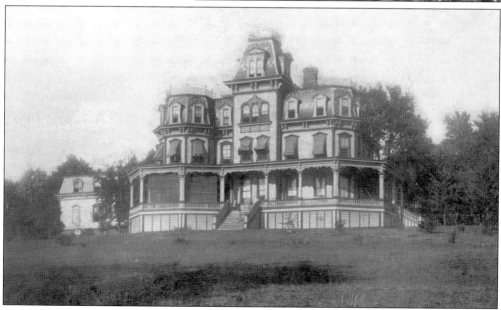

Oweno, a 30-room Victorian mansion on 350 acres, had a stable, a hennery, a carriage house, and a reservoir where fish were raised. Miller kept fine horses, cattle, poultry, Southdown lambs, and two domesticated American buffalo, employing many local people on his farm. The mansion burned in 1899, adding impetus to the effort to found a local fire company. The nucleus of the Miller estate became the development Cragmere Park. (Courtesy of Mahwah Library.)

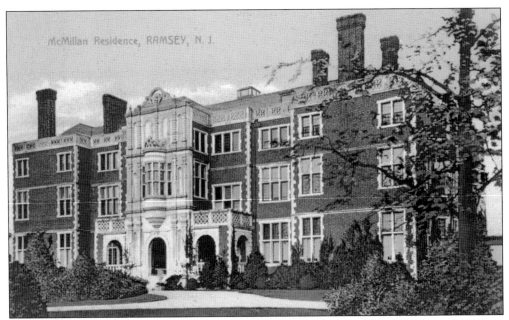

George Crocker, the son of a California railroad magnate, bought Alfred Darling's 1,100-acre estate in 1901 and built this magnificent 75-room Jacobean manor between 1902 and 1907. The mansion's exterior stonework and interior woodcarving are breathtaking. The property featured 16 greenhouses, a gazebo, a coach house, a garage, barns, and dairy facilities. The cost of the house, furnishings, and gardens was an unheard-of $2 million. The restored mansion is privately owned today. (Courtesy of Gene McMannis.)

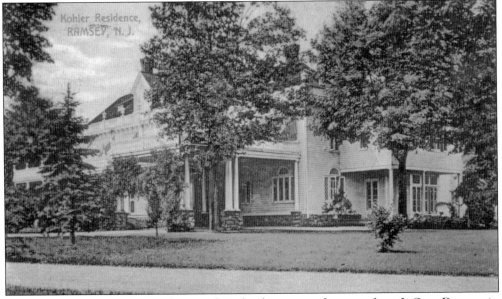

Charles Kohler, a piano manufacturer, bought the estate of sugar refiner J. Otto Donner in 1909, including the grand 1895 house. Kohler was a well-known sportsman, a New York Yacht Club member, and was passionate about breeding, owning, and racing horses. However, he died suddenly in Paris in 1913 at age 45. Today, the house has been returned to its former elegance as a single-family residence. (Courtesy of Gene McMannis.)

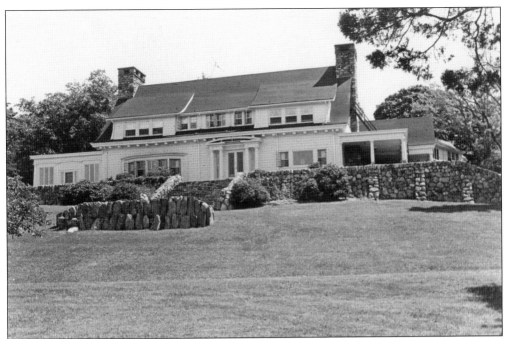

Charles Chapman, a New York stockbroker and investor, bought considerable Garrison family land in 1906 and built a farm estate, Welaivaben, on Ramapo Valley Road in 1911. It featured beautiful stone walls and outbuildings, and the farm employed many local people and included cows, poultry, horses, pigeons, quail, pigs, and produce. The 1929 crash forced Chapman to sell, and the property became the Carmel Retreat. (Courtesy of Mahwah Museum.)

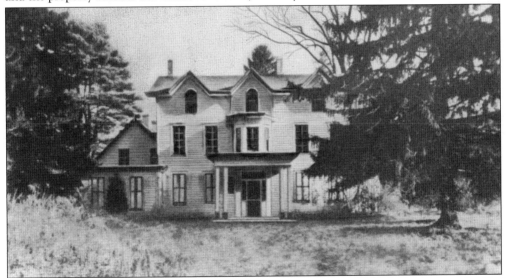

Rodman Price, the New Jersey governor from 1853 to 1857, is remembered as the "father of public education" for establishing the state's public school system. In 1862, he moved from Sussex County to the Ramapo Valley and established a premier dairy farm, Hazelwood on the Ramapo. This photograph of his manor house was taken when it was vacant in 1942. It is now Sun Valley Farm, privately owned and conserved through the New Jersey–Bergen County Farmland Preservation Program. (Courtesy of the author.)

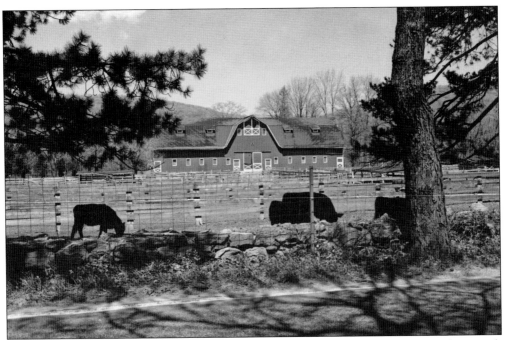

This stately 1881 barn from the Mountain Side Farm days commands center stage in this photograph looking west from Ramapo Valley Road. From 1940 to 1970, motorists enjoyed these views of scenic red barns and outbuildings, white fences, and the cattle raised by Stephen Birch Jr. The roadside trees originally planted by Havemeyer grew into a spectacular tunnel of trees, another favorite with motorists. (Courtesy of Mahwah Museum.)

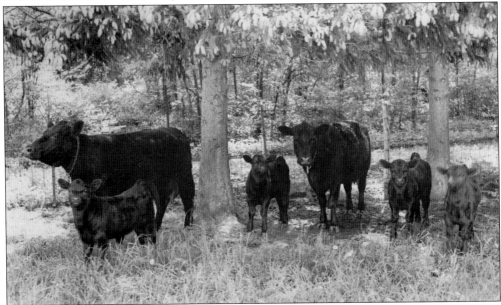

Stephen Birch Jr. bred and raised Aberdeen Black Angus cattle at Mahrapo Farm. Starting in 1948, large auctions of Mahrapo stock were held on the estate. Prices ranged from $300 to $3,100 per head, and one cow brought $10,000. Here, cows and young calves curiously observe the photographer. (Courtesy of Mahwah Museum.)

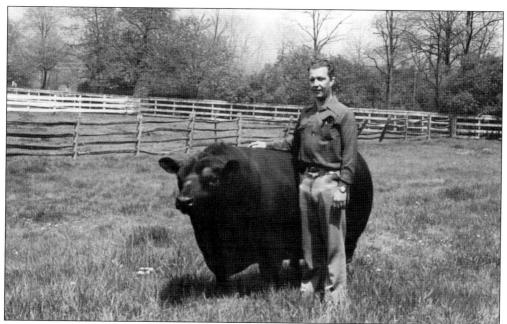

In the 1890s, Theodore Havemeyer sent Stephen Birch Sr. to Columbia Mining School. Birch later became wealthy helping Havemeyer and others invest in Alaskan copper mines. After Havemeyer's death, Birch bought 700 acres of his land and the Mayer mansion in 1917, where he and his family lived. Stephen Birch Jr., seen here, inherited the estate in 1940, changed the name to Mahrapo Farm, and began raising Black Angus cattle. (Courtesy of Mahwah Museum.)

After Stephen Birch Jr. died in 1970, some of his land on Ramapo Valley Road and the mansion were sold to Ramapo College of New Jersey. Birch's sister Mary kept a parcel with a house, outbuildings, and the 1881 barn. Eventually, this became the property of the Dator family of Mahwah, and it is now a conserved farm in the New Jersey–Bergen County Farmland Preservation Program. (Courtesy of Mahwah Museum.)

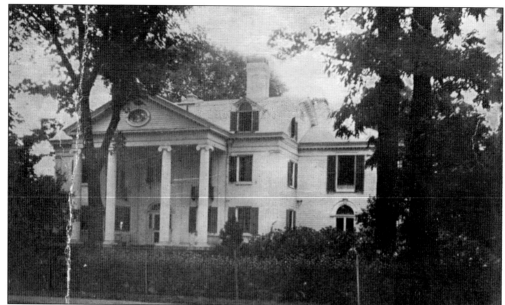

Around 1860, the Bockee family elaborately remodeled a valley house. Theodore Havemeyer purchased it in 1880. His son Henry O. Havemeyer took ownership in 1914, and, in 1917, remodeled it into this Newport-style mansion, with a chapel, magnificent formal gardens, and reflecting ponds. Henry Havemeyer died in 1965, and arsonists burned the house in 1970. His son Henry O. Havemeyer Jr. (1903–1992) lived in the Hagerman-Havemeyer mansion. (Courtesy of Mahwah Museum.)

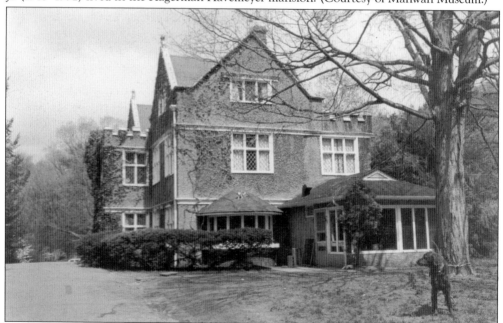

This graceful English-style country house on Ramapo Valley Road, known as the William Hand Estate, was designed and built around 1906 in the style of Rudyard Kipling's home in England. Facing west, the views of the mountains beyond the river are spectacular. There is an attractive pergola, as well as an elaborate stairway system leading down to the Ramapo River. (Courtesy of Mahwah Museum.)

Four

FAMILY FARMS
OF THE 1900s

Self-sustaining plots of land defined rural New Jersey in the first half of the 1900s. Mahwah was home to numerous family farms, passed from one generation to another, growing and raising food for their own consumption and for sale to others who populated the region.

Farmers maintained peach and apple orchards, grew vegetables and flowers, raised poultry, and produced eggs. Farm stands selling corn, tomatoes, squash, peas, berries, and the like graced the area. Some farms burgeoned into large retail operations, selling plants, flowers, fruits, and vegetables to an increasing number of residents.

In the 1950s, suburbanization, the phenomenon of people working in cities while living in ever-expanding areas outside the city, led to a large percentage of the population not growing any food of their own, instead purchasing it from grocery stores and supermarkets. Family farms began to diminish as land values skyrocketed and farming costs increased. One by one, Bergen County's landmark farms disappeared, and housing developments, condominiums, and commercial buildings took their place.

Mahwah remained rural longer than other towns in Bergen County partly because it was the farthest north. Most Mahwah farms, however, eventually yielded to development as farmers aged, regulations encroached on profits, and attractive offers for land persisted.

Today, less than one percent of the land in Bergen County is devoted to agriculture: 1,117 acres. However, a devoted contingent in Mahwah still farms their own land, with many supporters. The remarkable success of local farmers' markets attests to a passion that still exists for staying connected to the earth. There are four privately-owned farms conserved in Mahwah through the New Jersey–Bergen County Farmland Preservation Program: Sun Valley Farm, Mahrapo Farms, Deepdale, and Lottie's Farm. Secor Farms still operates the same large farm and market they opened in 1913.

Mahwah's family farms of the 1900s are a unique, heartwarming part of its history, and still important to many people.

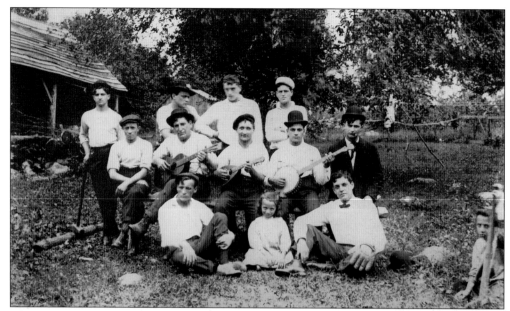

The Retaliate family of Campgaw Road, who were fun-loving and musical people, enjoys a family gathering with guitar, mandolin, and banjo music. They are nicely dressed and it is likely springtime, as the beans have not yet begun to climb the pole-racks in the background. The Retaliates were peach farmers in the Fardale section of Mahwah. (Courtesy of William Laforet.)

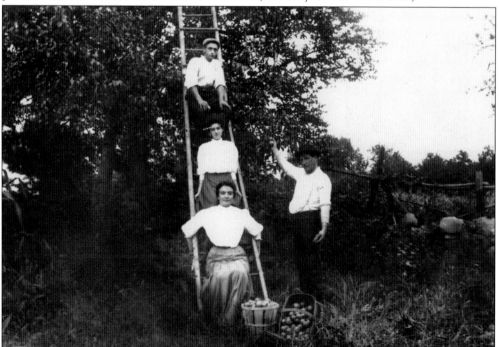

Peach-picking season was a family affair for the Retaliate family, with everyone, young and old, participating. Most farmers in the Fardale and Masonicus areas chose to take their produce to Paterson markets and sell directly to housewives, commission men, restaurants, and others, rather than use middlemen or ship them by train to New York City. (Courtesy of William Laforet.)

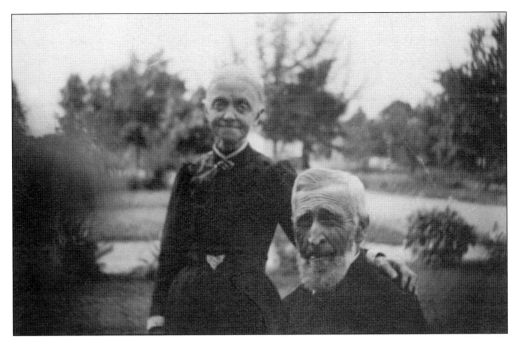

William J. and Amelia Valentine of Fardale are typical of rural Mahwah a century ago. They are well dressed, and the property in the background is well maintained. In the traditional manner of posed photographs of the day, the man is seated and the woman is standing. (Courtesy of Thomas and Jo Heflin.)

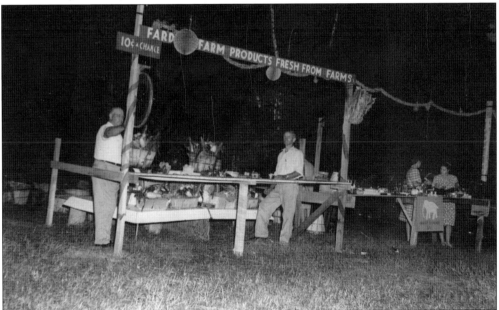

The sign at the annual Fardale bazaar reads, "Fardale Farm Products Fresh From Farms: 10¢ a Chance." There was a farm stand at this location (not shown) for decades. Attendance declined in the 1950s, and the event was discontinued. On the depot side of town, the Mahwah Garden Club discontinued its annual country fair and flower show around the same time. (Courtesy of Thomas and Jo Heflin.)

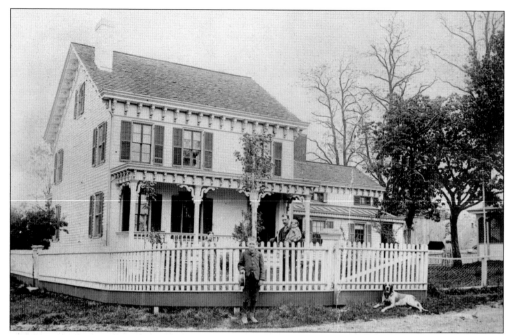

The Hopper family home, dating to the late 1800s, was on the hill above the Hopper gristmill, on the Ramapo River across Ramapo Valley Road. It was a large farmhouse with gingerbread-style influences. (Courtesy of Mahwah Museum.)

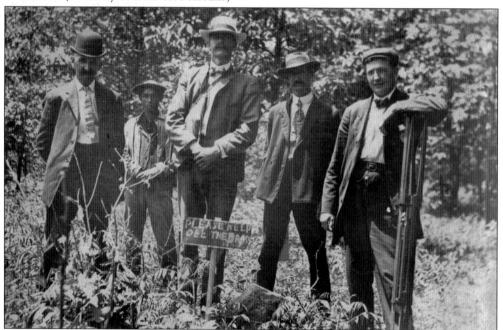

The Hopper farm was being surveyed on June 7, 1908, when this photograph was taken. Judging from the sign, a boundary dispute was taking place. Much of the area now covered by Route 17 and its interchange with Route 202 was part of the farm. From left to right are Abe Banta, Dave DeGroat, Rip Wanamaker, Francis D. Hopper, and the surveyor, who is unidentified. (Courtesy of Mahwah Museum.)

Stanley Pelz, a peach and apple grower, converted chicken coops into a farm stand to sell corn, beans, and produce along with his main crops of peaches and apples. His wife, Arilla, and their daughter Judy worked at the stand. The Pelz farm, on Airmount Avenue in the Masonicus section of Mahwah, was sold to Secor Farms and made part of its complex of greenhouses and retail farm stand. (Courtesy of Judy Pelz Coughlin.)

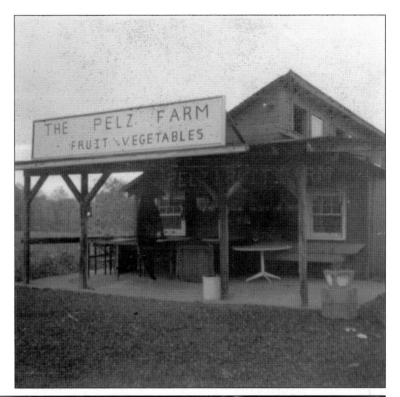

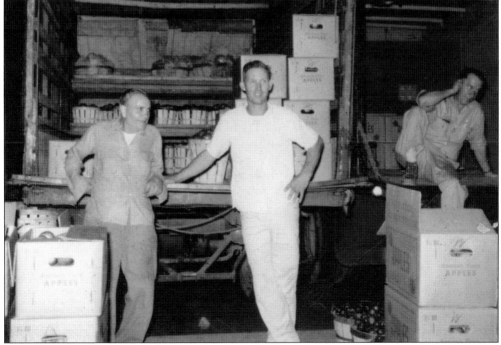

Stanley Pelz (center) is seen here at the Paterson Farm Market unloading peaches, apples, and produce. Many local farmers hauled their produce to this central market, where small grocery stores and restaurants bought in bulk for resale in their retail businesses. (Courtesy of Judy Pelz Coughlin.)

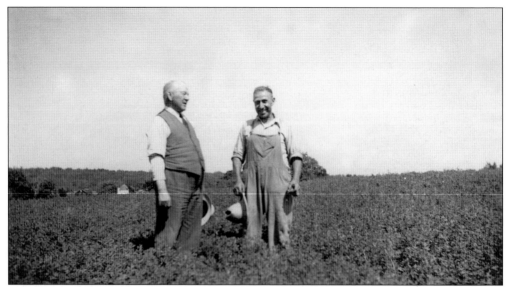

In this congenial, un-posed snapshot, prominent Mahwah farmer, entrepreneur, and benefactor Albert Winter (left) meets with Gary Cook, his good friend and neighboring farmer, in a field to discuss farm matters. Winter was prominent in local agriculture, working with dairy, corn, beans, and other vegetable crops as well as being a coal, feed, and grain dealer. (Courtesy of Mahwah Museum.)

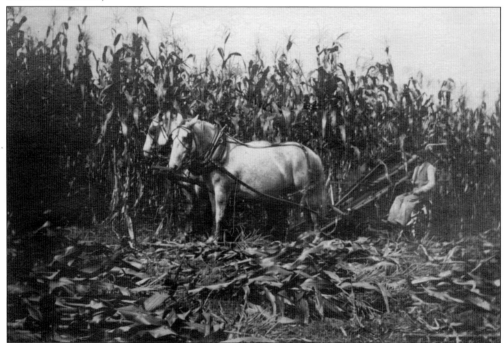

A field worker skillfully maneuvers a team of handsome white draft horses along dried, standing corn stalks in one of the Winter fields. Slow hand methods like this were eventually replaced by machines. A tractive-powered McCormick Shocker could quickly cut, gather, bind with twine, and expel one-foot diameter shocks of dried corn stalks to be retrieved by a following crew. (Courtesy of Mahwah Museum.)

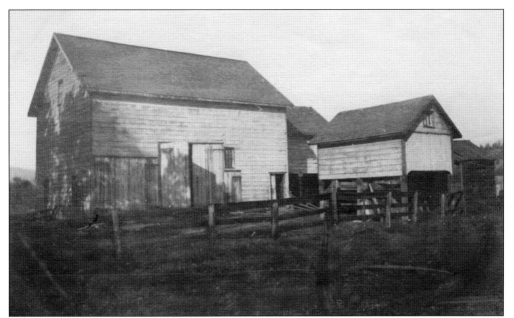

Albert Winter (1870–1944) started a dairy farm in these barns in the depot section of town, and then moved to Ridge Road. Winter's Mahwin Farms became one of the largest dairy cattle breeding and distribution farms in Bergen County, delivering milk from Oakland to Sloatsburg. The dairy was known for its excellent service and the high quality of its milk and cream. (Courtesy of Mahwah Museum.)

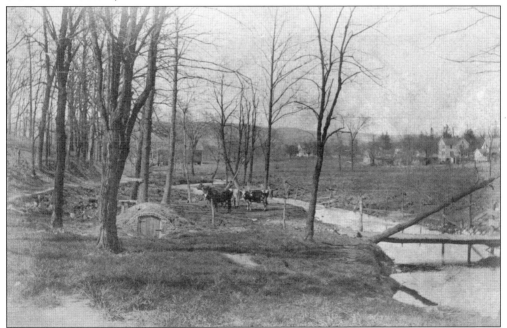

Dairy cows from the Winter herd forage along Winter's Brook. Devine Drive is to the left and Railroad Avenue is to the right. The small, arched stone structure with the door is a root cellar, in which root vegetables such as carrots, turnips, and parsnips were stored over the winter in cool, but not freezing, underground space. (Courtesy of Mahwah Museum.)

Originally a Pelz Farm fieldstone barn, this building became "Chad's barn," across from Chad's Farm Stand on Airmount Avenue. Tony Chadoroski married Alvina Pelz and operated the farm into the 1980s. Alvina made weekly trips to New York City's Hunt's Point Market with her specialty produce of tomatoes, peppers, French beans, and flowers. The barn is now preserved as a condominium association community hall. (Courtesy of Mahwah Museum.)

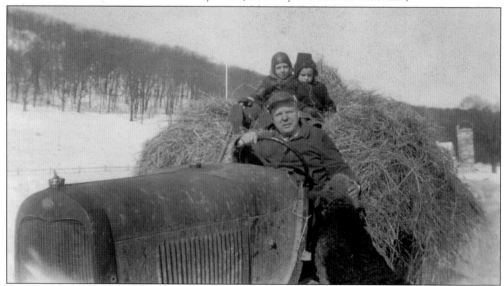

Sun Valley Farm, formerly Gov. Rodman Price's Hazelwood on the Ramapo estate, was purchased by Fred and Margaret Wehran in 1942. Once about 1,000 acres, the remaining 200-plus-acre preserved farm still produces large amounts of hay. This 1945 photograph shows Fred Wehran, his two children, and the family dog on a 1929 Ford automobile that was converted to tractor use during the World War II years. (Courtesy of the author.)

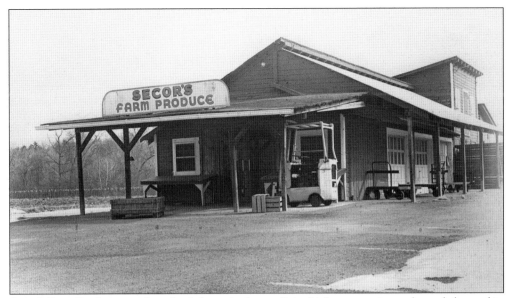

Secor's Farm Produce stand was built from the former Pelz chicken coop. It was formerly located in Upper Saddle River on land severed by Route 2 (now Route 17) and developed into condominiums and large office complexes. This quaint, nostalgic farm stand belies the magnitude of the Secor operation today, which includes extensive greenhouses and modern buildings. (Courtesy of Mahwah Museum.)

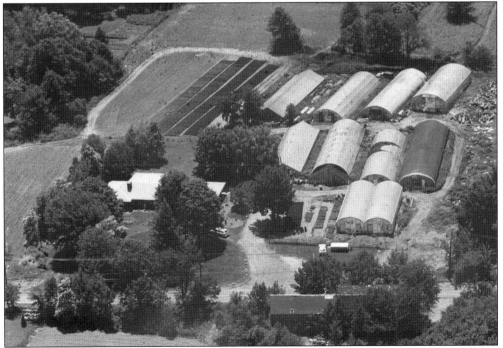

Rozanski's Nursery, on Masonicus Road across from the former Company No. 3 firehouse, is seen in this aerial view. Established in 1917 by Walter and Frances Rozanski, the farm had extensive greenhouses for growing potted flowers, producing at peak 25,000 pots of chrysanthemums per year. The family kept the nursery in operation until 1992. (Courtesy of Kathy Brewster.)

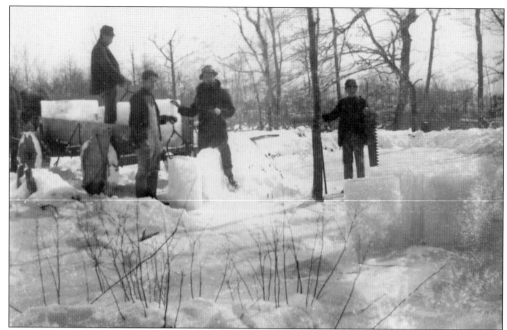

The Retaliate family is seen here with a harvest of ice blocks for their icehouse, where summer crops were preserved through the hot months. The Retaliates had large holdings on Campgaw Road. While the house still stands today, most of the outbuildings are gone. One of the successive occupants and farmers was Raymond Saufroy, who marketed French herbs and savories into the 1970s. (Courtesy of William Laforet.)

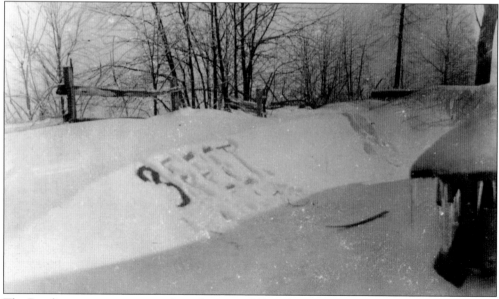

The Retaliates commemorate a three-foot snowfall in the 1930s. That much snow is not easy to manage today; imagine what it was like in rural Mahwah with rudimentary equipment to clear the way. Into the 1940s, farmers often reverted to horses to pull angle plows when tractors could not go in the snow. Draft horses also pulled timber sleds and sleighs, both in the woods and on "improved" roads. (Courtesy of William Laforet.)

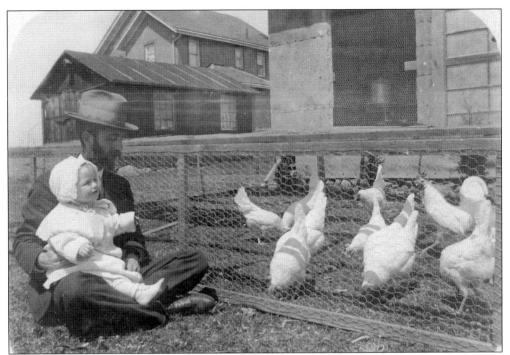

Havilah Smith holds his daughter Isabel while explaining chickens to the infant. Almost everyone in Mahwah kept chickens for eggs and meat. Isabel Smith Hudson, who grew up in Cragmere Park, amassed a large collection of photographs and articles about Mahwah during her lifetime and donated it to the Mahwah Museum. This family photograph dates to the 1920s. (Courtesy of Mahwah Museum.)

This late 1700s Dutch barn belongs to Amberfields, an early farm on Ramapo Valley Road. The steeply pitched roof sheds winter snow, allowing sunlight to warm the loft, where herbs and vegetables were dried. The over-height center door allowed a hay wagon into the barn to be unloaded to the sides onto racks for curing and storage. The barn still stands and is in good condition. (Courtesy of Kathy Lord.)

Farming required a tremendous amount of labor but could also provide great entertainment for children. This photograph shows members of the Storms family, who farmed in the Fardale section of Mahwah, getting a ride in the wheelbarrow. In the rear is Warren Storms, and the wheelbarrow is being pushed by his father, Frederick J. Storms. (Courtesy of Thomas and Jo Heflin.)

Ida Zabriskie and Jake Valentine enjoy a bowl of homemade ice cream, a summer treat made possible by the warm-weather storage of ice, fresh cream from the cow, and children to crank the handle of the ice cream maker. The apple barrel and hay bales in the background complete this typical farm scene in Fardale. (Courtesy of Thomas and Jo Heflin.)

Five

A STATION CALLED MAHWAH

Even after the Paterson & Ramapo Railroad laid tracks through Mahwah in 1848, there was still no defined center of town. Mahwah, at the northernmost end of Bergen County, was merely a flag stop, meaning that the train would stop there only if the part-time railroad revenue agent flagged it down. That agent was probably William Goetschius, the owner of the sawmill beside Winter's Pond, just a short walk to the makeshift platform. In 1852, the Erie Railroad leased the Paterson & Ramapo Railroad, putting Mahwah on the Erie main line.

Even though every important hamlet along the line had a station, some of which were palatial, the Erie Railroad Company did not seem interested in locating a depot at Mahwah. Finally, influential citizens convinced the reluctant railroad that enough passenger and freight revenue would be generated by one, and a depot was built in 1871 on land reportedly donated to the railroad by Albert Winter. The citizens named the depot Mahwah, after the name of the early settlement and the Indian field Mawewi.

The station was small, plain, and shaped rather like a birdhouse, with large, exaggerated overhangs for weather protection. Nonetheless, it had the power to change destiny. No longer would farmers have to laboriously travel to nearby Suffern, Oakland, or Ramsey's Station for shipping and serving new markets. An even more important effect of the depot was that it attracted affluent entrepreneurs who could commute to New York City. Ezra Miller, an inventor, bought a large tract of land in 1872 to develop Oweno on the hillside overlooking the depot area. His property later became Cragmere Park.

Alfred B. Darling, the owner of New York's prestigious Fifth Avenue Hotel, established Valley Stock Farm in the Ramapo Valley in 1872, and, subsequently, the hamlet of Darlington. People of this stature brought new ideas and worldly perspective to Mahwah, as well as the funding to implement their plans. Miller and Darling started the trend, and more followed. Another benefit of the depot, on a smaller scale, was the gaily clad vacationers who frequented Mahwah's seasonal tourist establishments and boardinghouses to escape the heat of the cities.

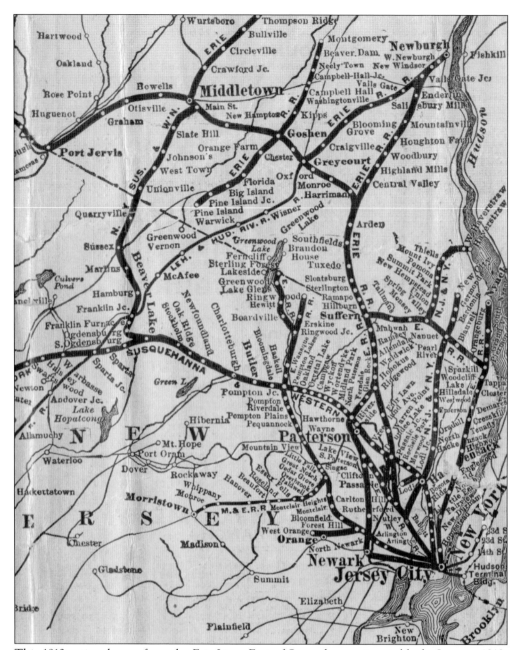

This 1912 regional map, from the Erie Lines East of Susquehanna time table for January 1912, offers a partial view of the Erie Railroad network in New Jersey, New York, and Pennsylvania. Mahwah is shown as a full station stop with a white dot. The expansion of railroads, offering easy access to previously remote locations, led to rapid development of the region. (Courtesy of the author.)

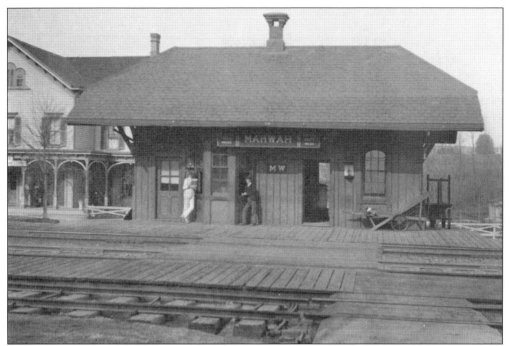

The 1871 Erie station at Mahwah was photographed in 1895 by Henry O. Havemeyer. To the left of the station is the A.J. Winter & Son general store. At the right is the pedestrian walkway crossing the tracks and leading to the Mahwah Hotel, Franklin Turnpike, and the Cragmere area. (Courtesy of Mahwah Library.)

This photograph shows the Erie station on the right and the Winter feed and grain storage building on the left. The Winter family store, east of the tracks, began selling feed and grain, coal, and lamp oil (kerosene) as early as 1870. Beyond the baggage cart is the old Ramapo Avenue level-grade crossing that was used before the railroad bridge was constructed. (Courtesy of Mahwah Library.)

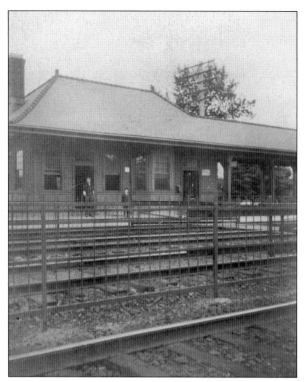

A new 1904 station was part of the redevelopment of the entire depot area. The old level-grade crossing was eliminated and East Ramapo Avenue was rerouted under a new railroad bridge; the two sets of tracks were expanded to four, with slower freight on the inside tracks; land was set aside for Depot Park; and the 1871 station was saved from demolition by moving it off-site to storage. (Courtesy of Mahwah Museum.)

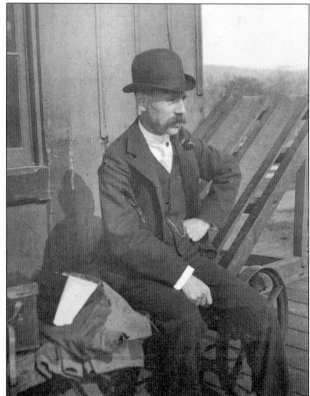

John F. Mayer was photographed here by his brother-in-law Henry Havemeyer while awaiting a train. Mayer was married to Theodore Havemeyer's daughter Nathalie, and they lived at Mountain Side Farm. (Courtesy of Mahwah Library.)

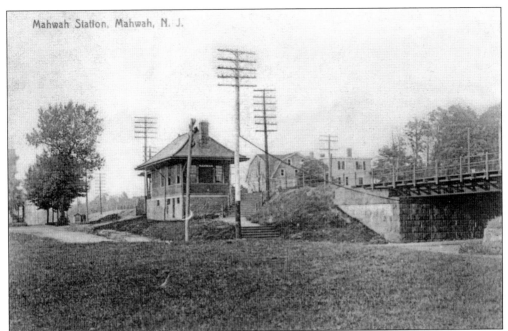

Mahwah Station, Mahwah, N. J.

This rear view of the 1904 station shows the rerouting of East Ramapo Avenue under a new railroad bridge, which was a much safer way to cross the tracks. On the far side of the tracks is the gambrel roof of the Mahwah Hotel and the starkly square building that formerly held John Winter's grocery store. The depot section was becoming the center of town. (Courtesy of Gene McMannis.)

Judge John Quackenbush, one of Mahwah's earliest commuters, was photographed here at the station by Henry O. Havemeyer in 1894. The judge and his family lived on Island Road and maintained a dairy farm. He commuted daily to the New York City Customs House in lower Manhattan, where he was a customs official. (Courtesy of Mahwah Library.)

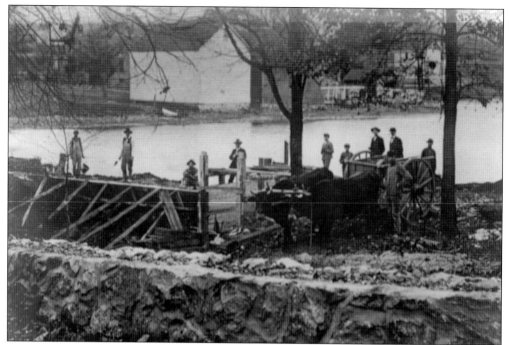

In 1904, the old Winter millpond dam was rebuilt. Also, a new, elevated section of East Ramapo Avenue and a new county bridge were built. Note the oxcart and the team of oxen between the two trees. In the background are Winter's Pond and Winter's commercial icehouses, still in use on the opposite shore. (Courtesy of Mahwah Museum.)

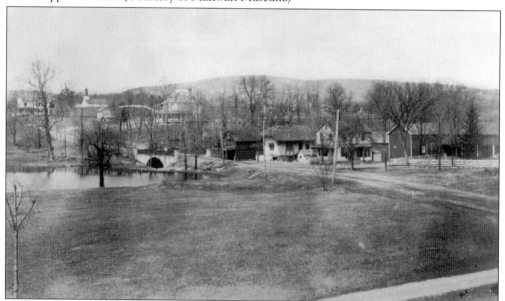

If Mahwah had an official main street, it would be East Ramapo Avenue. Seen here on the left is Winter's Pond; the East Ramapo Avenue county bridge, built in 1905 and enlarged in 1915; the 1871 station, in storage across from Winter's Pond; Happy Devine's blacksmith shop, to the left of the station; Albert Winter's dairy store, to the right of the station; and Winter's barns, in the right background. (Courtesy of Mahwah Museum.)

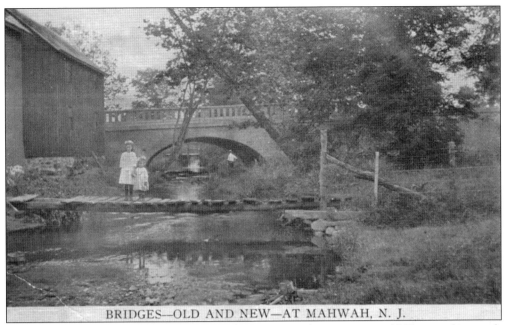

BRIDGES—OLD AND NEW—AT MAHWAH, N. J.

The newly rebuilt East Ramapo Avenue Bridge is seen in this picturesque 1912 view of its north side and decorative top railing. Two young girls pose on a wooden footbridge across Winter's (Masonicus) Brook. (Courtesy of Mahwah Museum.)

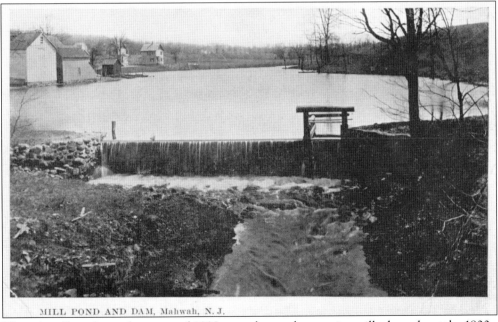

MILL POND AND DAM, Mahwah, N. J.

Winter's millpond, seen here around 1900, served several successive mills throughout the 1800s. The old dam was made of tightly jointed cut stones. The sluice gate, to control the water level, is on the right. In winter, ice from the pond was stored in the icehouses on the left. The Winter business was set up to sell coal in winter and ice in summer. (Courtesy of Gene McMannis.)

The idea for Depot Square Park came about when the new 1904 station was planned. By extending East Ramapo Avenue to Franklin Turnpike, with Miller Road and the new connector along the tracks (left), there would be road frontage on all four sides—just right for a park. The distinctively square John Winter store is on the left and Lavina Hopper's house and barn are on the right. (Courtesy of Mahwah Museum.)

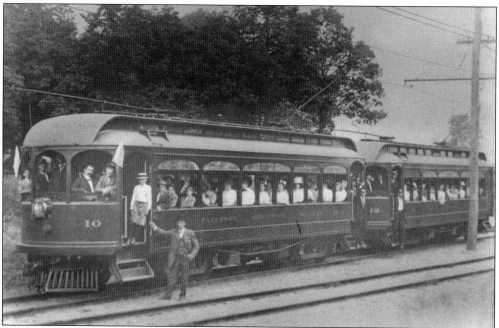

The North Jersey Rapid Transit electric trolley ran from Suffern to a connection with the public service trolley line in East Paterson. It served commuters and shoppers to the center of Paterson and provided a cleaner alternative to trains fueled by coal. This photograph is of a Sunday church outing. Mahwah's stop was at the Henrietta Building, across from Fire Company No. 1 on Miller Road. (Courtesy of Mahwah Museum.)

This early photograph of Depot Square was taken around 1920. The stone wall in front appears to be recently built. Beyond the flagpole, a trolley is headed towards the Henrietta Building, seen on the left. A trolley stop was located on the east side of the Henrietta Building. (Courtesy of Craig Long.)

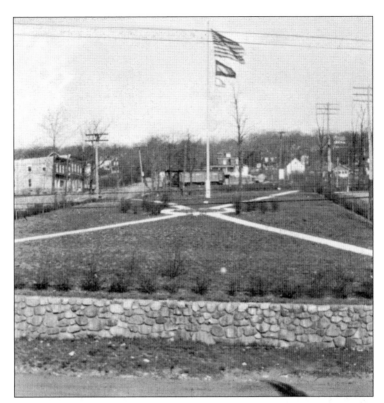

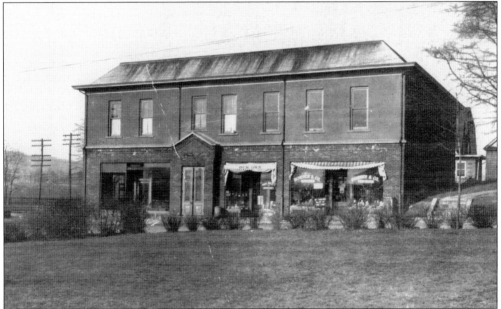

Built by Albert Winter in 1915, this building replaced the old John Winter store building. The grocery store in this new location was purchased by the Scherers in 1919. There has been a grocery store on this site for over 150 years, with the Scherers' ownership lasting more than 94 years. The town government also leased space here from 1915 to 1929, and the post office was in the building from 1915 to 1967. (Courtesy of Craig Long.)

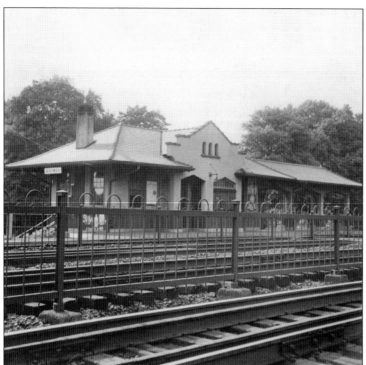

The 1904 station, only 11 years old, burned to the ground in 1915. The *Suffern Independent* reported that Mahwah was entirely without fire protection, and young men were talking about organizing a fire department and purchasing a chemical engine. The mission-style station seen here was built in 1915, becoming the third station building in Mahwah. It still stands today. (Courtesy of Mahwah Museum.)

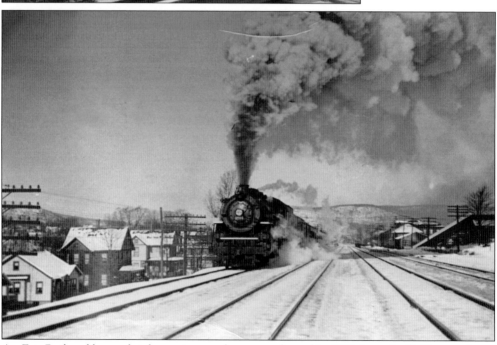

An Erie Railroad heavy freight engine accelerates eastbound in 1941 from the Suffern yard as it passes through Mahwah. Smoke and steam under high pressure blast from the stack. The freight "consist" was probably of high priority in those months before World War II, since it is "high balling" on the faster passenger track. South Railroad Avenue is on the left and Winter's railroad siding and coal conveyor are on the right. (Courtesy of Mahwah Museum.)

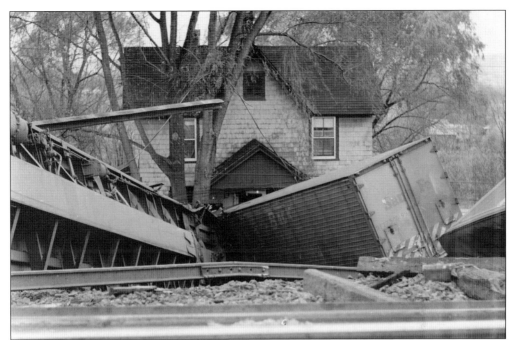

On November 16, 1970, at 4:56 a.m., 14 piggyback freight cars of a 40-car Chicago–New York train derailed on the main line tracks of the Erie-Lackawanna Railroad in Mahwah. As the derailment escalated, refrigerated trailers were torn loose from the flatcars, crashing at high speed into the ground and the adjacent tracks, spilling their contents in a wild jumble of twisted metal, boxed appliances, and sides of chilled beef. A nearby resident said that she heard terrible, deafening noises and saw railroad cars hurtling towards houses. A trailer slammed into a three-family home at 118 North Railroad Avenue, pushing it more than two feet off its foundation. Amazingly, no deaths or injuries resulted, and, within 30 hours, the rails were back in service. The left track in the photograph below is the American Brake Shoe siding. (Both courtesy of Mahwah Museum.)

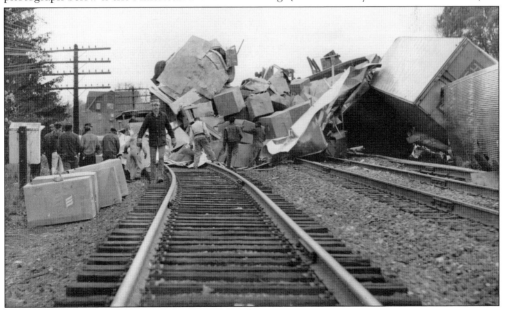

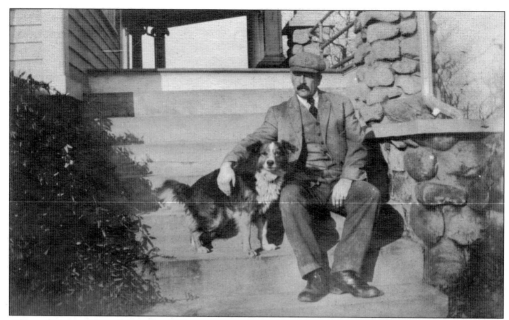

Albert Winter (above) was the fifth generation of successful Mahwah entrepreneurs, originating with his great-great-grandfather, who owned the local sawmill in the 1790s. Today, that millpond is Winter's Pond. Throughout the first half of the 1900s, Winter was the most influential businessman, civic leader, and philanthropist in Mahwah. He amassed large landholdings and established Mahwin Farms, a major cattle breeding and dairy operation, started a water company, was the local tax collector, faithfully supported his church, and was generous towards community causes. His forebears would have been proud. The coal bunker below stood on the site of the A.J. Winter & Son feed, grain, and coal yard on Depot Square in Mahwah, which was served by its own siding. The Winters had been leading coal dealers since 1870. (Both courtesy of Mahwah Museum.)

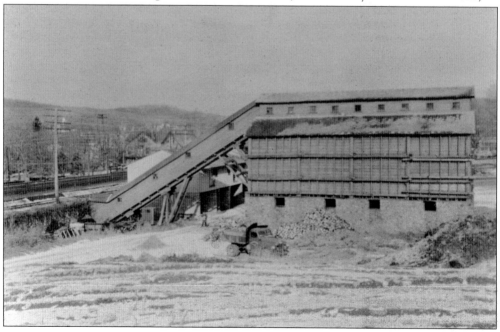

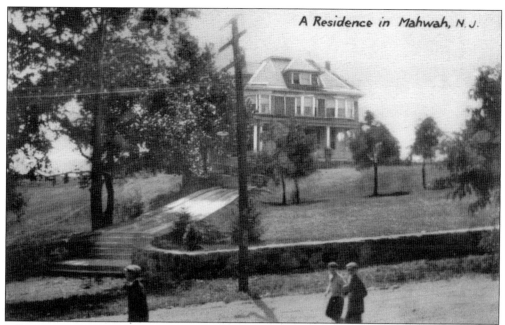

A Residence in Mahwah, N.J.

Albert and Annie Winter's lovely home, known as the "house on the hill," was built in 1907. The couple bequeathed their property, with the large house, pond, and 17 acres, to the residents of Mahwah. While it was being prepared to serve as the next town hall, the house caught fire four times, with arson suspected. The damage was irreparable. Nonetheless, the scenic pond and land are still used and enjoyed by townspeople every day, exactly as the Winters wanted. Improvements to the facilities and ideas for expanded uses of the park are always taking place. The photograph below, from the mid-1960s, shows the beginnings of the development of the park. (Above, courtesy of Mahwah Museum; below, courtesy of Gene McMannis.)

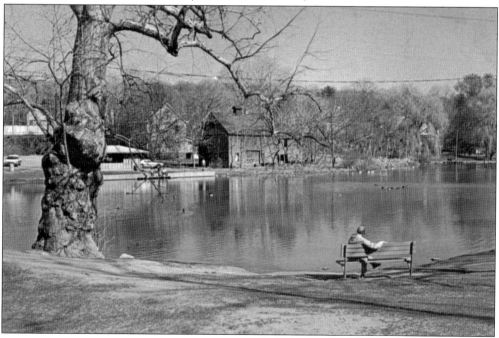

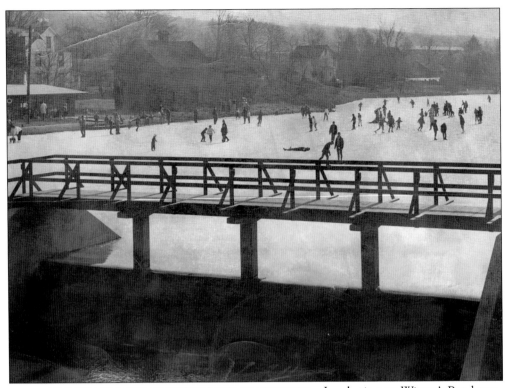

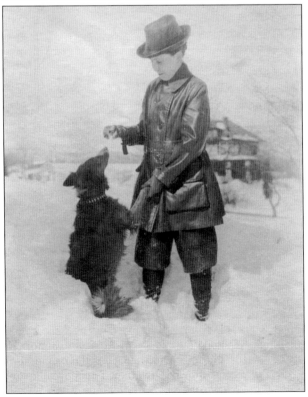

Ice-skating on Winter's Pond was a common sight in the 1970s, as seen here. However, as farms disappeared and irrigation ponds were filled in, it became difficult to find places to skate, and the sport declined in popularity. Also, warmer winters have not produced the hard, thick ice that is safe for large groups of skaters. (Courtesy of Kay Yeomans.)

Annie Carpenter Winter, who grew up on Alfred Darling's Valley Farm on Ramapo Valley Road, devoted her life to Mahwah's causes, particularly the Mahwah Library, housed in the Henrietta Building, and, after 1949, in the Winter Memorial Library. She served for 40 years as library board chairwoman. She is seen here in the 1920s playing with one of her many dogs. (Courtesy of Mahwah Museum.)

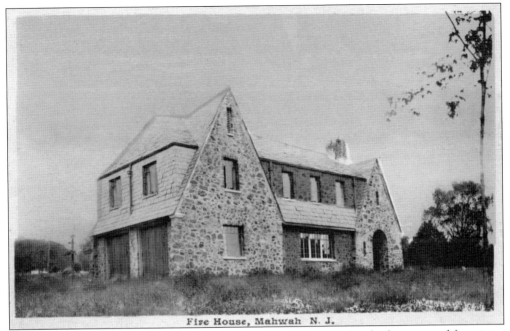

Fire House, Mahwah N. J.

The Miller Road Company No. 1 firehouse, erected in 1929, served multiple municipal functions. On the first floor was the fire department, which is still there today. The second floor housed the town hall from 1929 to 1958, and the Mahwah Police Department from 1930 to 1958. (Courtesy of Mahwah Museum.)

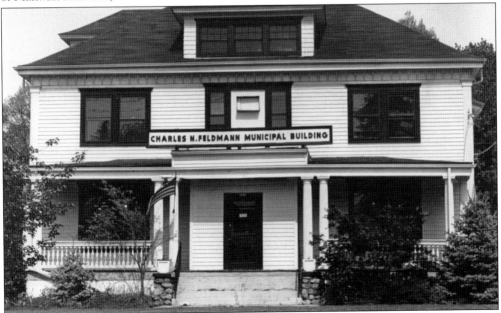

CHARLES N. FELDMANN MUNICIPAL BUILDING

In 1957, the township acquired a 10-room house for administrative services and the police department. The new Charles Feldmann Municipal Building soon became inadequate for both entities, and multiple annexes were created. Finally, a dedicated police station was built in 1974, and in 1991, the municipal services moved to a building on Corporate Drive. The current town hall was built on Corporate Drive in 2003. (Courtesy of Mahwah Police Department.)

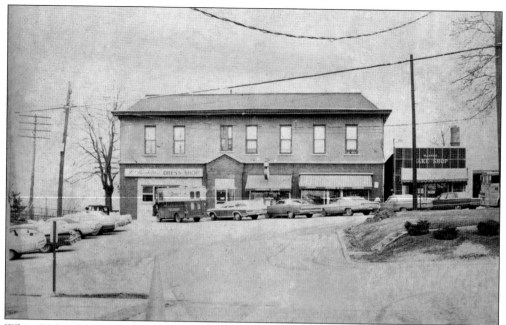

When Mahwah's first postmaster was appointed in 1870, the post office was located in the Mahwah Hotel. It then moved to the Van Horn–Winter–Dederick general store, and then to the Erie railroad station. In 1915, it was moved again, from the station to the new Winter Building, seen here, where it remained until the present post office was built in 1967. (Courtesy of Mahwah Museum.)

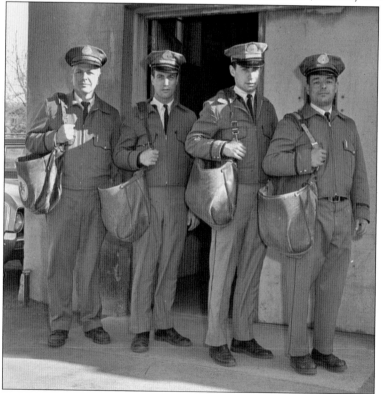

These four walking letter carriers, in full uniforms and neckties, pose outside the new 1967 post office as they start their routes, delivering packages, letters, postcards, magazines, and the never-ending stream of advertisements. (Courtesy of Mahwah Museum.)

The Mahwah Library was begun in 1912 by Eleanor Bugg at her home in Cragmere Park. Soon after, it was moved to a nearby carriage building. From 1920 to 1949, it was in the Henrietta Building on Miller Road, seen here. The early 1900s building was home to many Mahwah services and businesses over the years, including a movie theater, and was the location of the trolley stop until 1929. (Courtesy of Mahwah Museum.)

Funded by a bequest from Albert Winter in 1949 and an additional gift from Annie Winter, the handsome new 1950s-style Winter Memorial Library was built on Franklin Turnpike. The library served the township until 1998, when the present Mahwah Public Library on Ridge Road opened its doors. The Winter Memorial Library building is now the home of the Mahwah Museum Society. (Courtesy of Mahwah Library.)

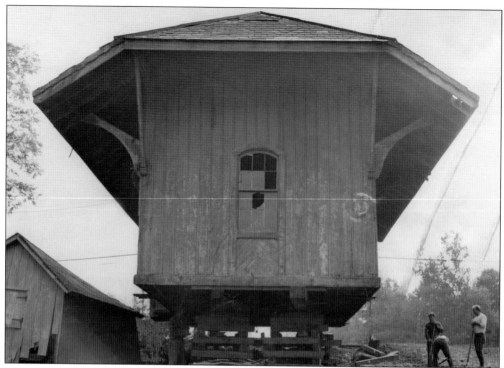

The old 1871 railroad station is seen here being moved for a second time. It is jacked up on wood cribbing to be moved 200 feet to its present location, seen below. In 1904, the sturdy structure had been moved west and placed between the blacksmith shop and Winter's retail dairy store on East Ramapo Avenue. It was used as a storage building. (Courtesy of Mahwah Museum.)

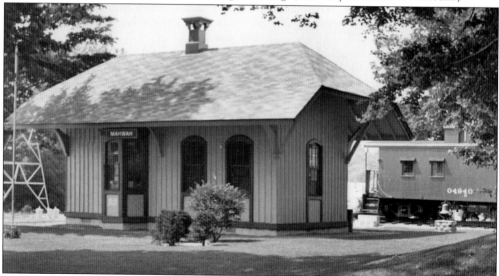

The 1871 Mahwah depot building, now in its third location, is used as a railroad museum today. The stationmaster's bay window gave him a view of the track in both directions. Heated by a large potbellied stove, passengers were warmed until the arrival of their train, usually on time. The Erie Railroad caboose in the background has been restored by the Mahwah Museum Society. (Courtesy of Mahwah Museum.)

Six

SMOKESTACKS ON THE HORIZON

Brothers Josiah, Jeremiah, and Isaac Pierson established one of America's first nail factories in 1796 in Ramapo, New York. The Piersons' Ramapo Works comprised mill buildings, workers' houses, and a small church along the Ramapo River on Orange Turnpike (Route 17). Throughout the 1800s, the Piersons continued their manufacturing activities and helped to found the Erie Railroad.

In 1866, William Wait Snow and the Piersons founded the Ramapo Wheel & Foundry Company in Suffern, New York. In 1872, they founded Ramapo Iron Works in Hillburn. Snow's son Fred was superintendent. A relation, Elmer Snow, was also brought in to help. It was eventually decided to build a larger plant on the railroad tracks in Mahwah, and the new Ramapo Foundry Company opened there in 1901 with Elmer Snow as superintendent. In 1902, William Snow brought together three other brake shoe manufacturers with the Ramapo Foundry Company to form the American Brake Shoe & Foundry Company. There were 500 workers in Mahwah.

During the Depression, a light metals laboratory building was added with more employees. Over the years, more acquisitions and mergers resulted in a name change to the American Brake Shoe Company in 1943, and then to Abex in 1966. The headquarters of the Railroad Products Group of Abex remained in Mahwah until the plant closed in 1983.

The American Brake Shoe Company originally employed workers from Eastern Europe, who formed a community of their own in West Mahwah with two Catholic churches and small stores and services, often in homes. Many of the West Mahwah "company houses" still exist today.

The next heavy industry to come to Mahwah was Ford Motor Company, which opened in 1955. The sprawling assembly plant turned out an average of 1,100 vehicles per day. It closed in 1980.

Mahwah's first factory was the impressive but short-lived Hopkins & Dickinson lock works, a water-powered mill on the Ramapo River that produced high-quality locks and bronze fittings from 1872 to 1881. The company employed about 100 to 125 people and was located on Ramapo Valley Road in Darlington.

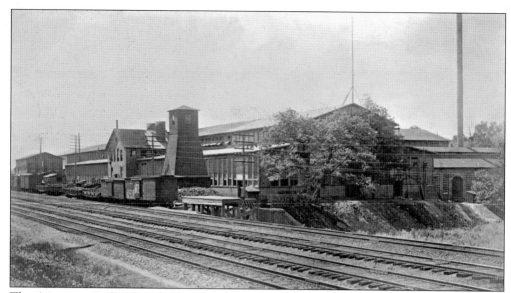

The American Brake Shoe & Foundry Company, seen here in 1903, was a highly developed industrial plant utilizing well-designed brick buildings along the four-track Erie Railroad main line. Note the attractive arched employee entrance on the far right. (Courtesy of Craig Long.)

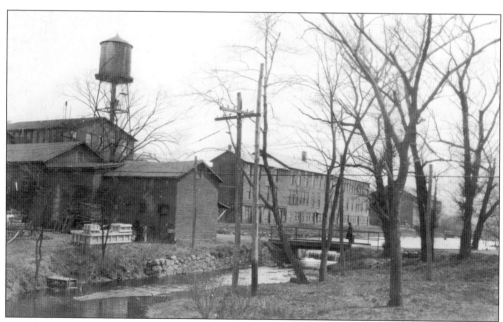

Foundry operations required large amounts of water for cooling, quenching, and fire fighting. Here, in April 1930, the American Brake Shoe & Foundry Company draws water from the Mahwah River (foreground) to fill its tank tower, which produced the needed water pressure. (Courtesy of Mahwah Museum.)

Female technicians performed quality-control tests on many products, especially during World War II when male employees went to war. Here, Mary Moran Durham observes length changes of the test bars in the testing section of the metallurgical department by special optical techniques. (Courtesy of Mahwah Museum.)

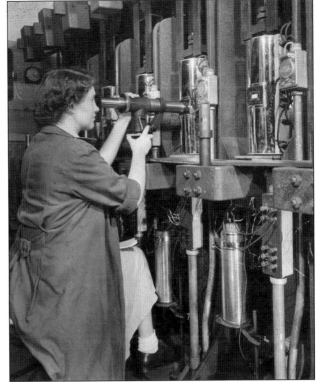

Below, foundry workers in 1944 pour experimental light-metal alloys in the test room, which utilized banks of electronic meters and gauges. The mold was for centrifugal casting of heat-resistant alloy. (Courtesy of Mahwah Museum.)

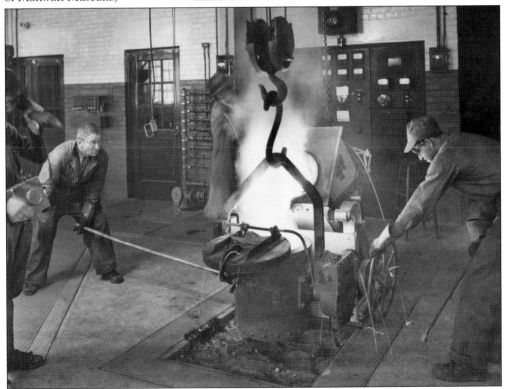

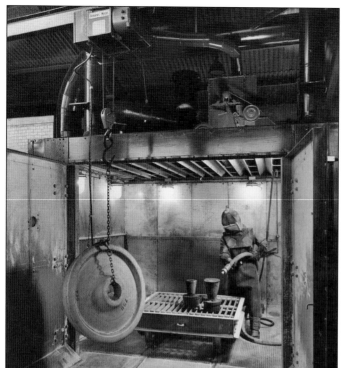

Here, in 1944, a worker in the blast room at the American Brake Shoe & Foundry Company sandblasts residual slag from a railroad casting. A railroad wheel is next in line. This was heavy, dirty work that required training and skill to use sand, shot, or grit to clean, but not ruin, the freshly cast iron part. (Courtesy of Mahwah Museum.)

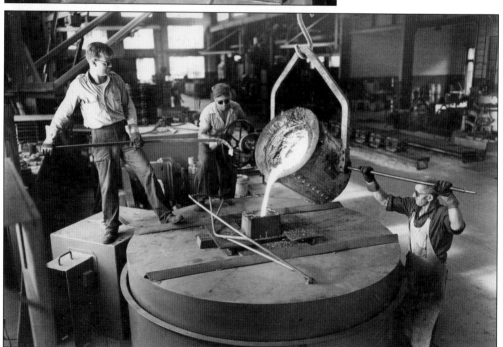

In 1948, molten metal is skillfully poured into a centrifugal casting barrel that contains one or more voids in damp sand in the shape of the desired parts. The American Brake Shoe Company produced both heavy iron castings and light-metal alloy products for railroads, ships, and military needs. (Courtesy of Mahwah Museum.)

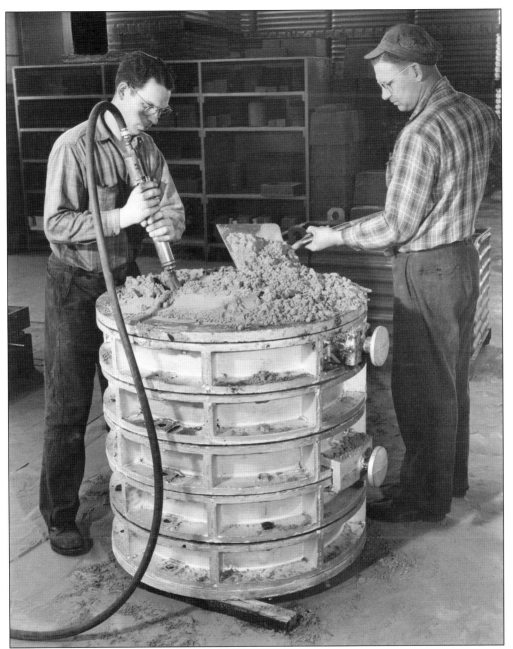

These workers tamp sand into a mold for centrifugal casting at the Brake Shoe Company's experimental foundry in 1944. This design is for a melting pot of special heat-resistant iron for casting light-metal alloy parts made of aluminum and magnesium. (Courtesy of Mahwah Museum.)

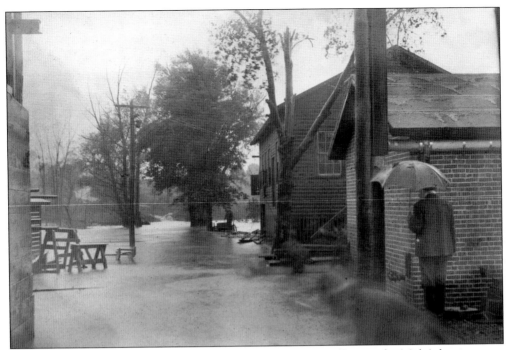

The great flood of 1903 devastated large parts of many river valleys in the Mid-Atlantic states. Here, Elmer Snow, the American Brake Shoe & Foundry Company superintendent, surveys the rising waters of Winter's (Masonicus) Brook as it and the Mahwah River engulf foundry buildings. (Courtesy of Craig Long.)

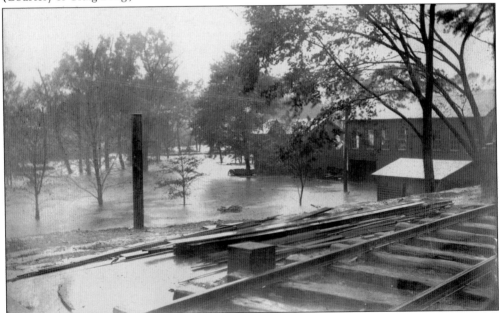

Although the Erie Railroad main line tracks were somewhat above the flood in this area, the lower-lying land, buildings, and industrial rail system of Mahwah's Brake Shoe plant did not fare as well. Mud and debris were the least of it; the foundations of several buildings were undermined and required extensive reconstruction. (Courtesy of Craig Long.)

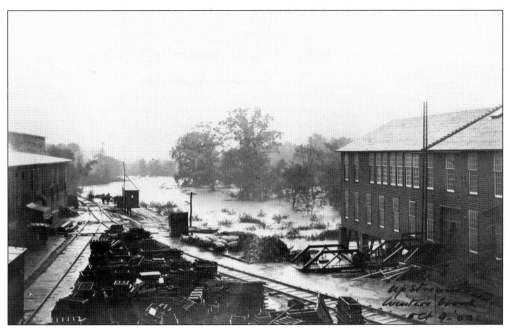

Winter's Brook, usually a quiet stream, became a raging torrent in the hurricane of 1903 and the resultant flood. Here, debris has washed up against the steel bridge, and boxes and crates that floated downstream have been piled between the railroad tracks on the property. (Courtesy of Craig Long.)

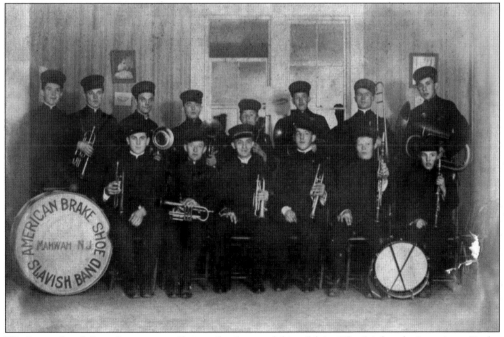

Work was hard, but there was still time for fun and friendship. The Mahwah American Brake Shoe Slavish Band attracted mostly younger men. Drums and brass instruments predominate in this company-sponsored band, which entertained at weddings, birthdays, and other celebrations. (Courtesy of William Trusewicz.)

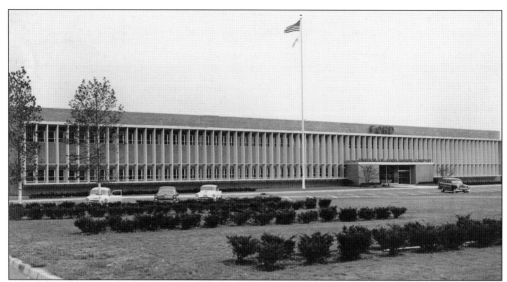

The front office of Ford Motor Company's Mahwah assembly plant is seen here in the 1950s. The Ford Country Squire in front of the entrance is joined by a Plymouth, a 1956 Ford, and a Pontiac. This plant turned out about 1,100 new cars per day. (Courtesy of Mahwah Museum.)

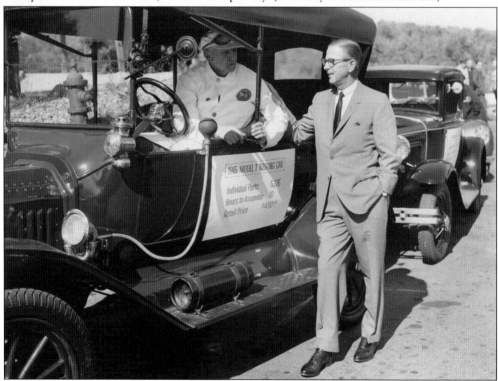

Celebrating the 50th anniversary of the Ford Model T in 1958, the Ford Motor Company organized a parade of Ford milestone cars in Mahwah. Here, Samuel Simmons, the plant manager, admires a 1909 Model T. Next in line is a Model A. Both are ready to proceed in the parade of 20 vintage Ford automobiles. Ford made 15 million Model Ts, putting America on wheels. (Courtesy of Mahwah Museum.)

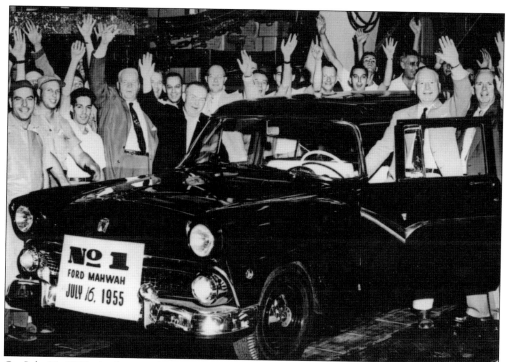

On July 16, 1955, the first production car rolled off the line at Ford Motor Company in Mahwah. The plant had been located in Edgewater, New Jersey. Many of the employees were retained and continued to commute to Mahwah from places as far away as Hudson City, New Jersey, and The Bronx, New York. (Courtesy of Mahwah Museum.)

This north-facing aerial view shows the sprawling Ford plant complex, with its 5,000-car employee parking lot, finished car storage, full rail yard, and parts staging sheds. At the top center are the newly completed Thomas E. Dewey New York Thruway and the Clove, the natural 14-mile pass through the mountains that was so important to early travelers. (Courtesy of Mahwah Museum.)

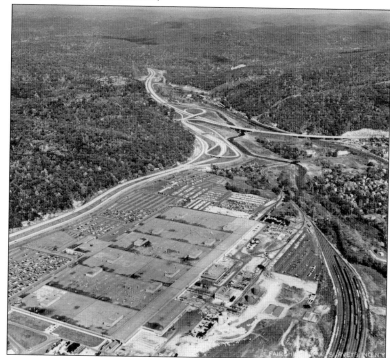

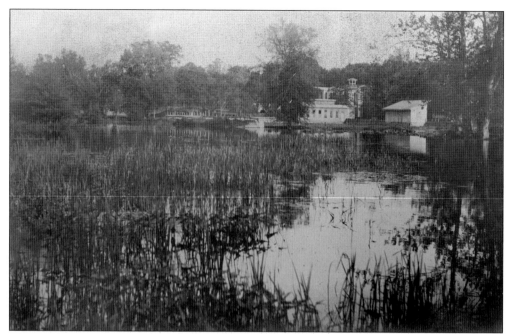

The Hopkins & Dickinson water-powered lock factory is seen here from across the Ramapo River. The factory's finished goods were taken in horse-drawn freight wagons to Ramsey's Station for shipping. The stone head race, turbine pit, and tailrace of the power-producing mill turbine still exist, a testimony to their designer and their skilled builders 130 years ago. (Courtesy of Mahwah Museum.)

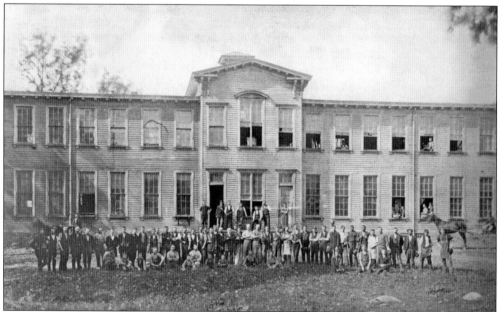

The Hopkins & Dickinson Manufacturing Company, which made brass locks and bronze fittings, was a large operation for its time (1872–1881). It was located on the Ramapo River south of Darlington Avenue and was powered entirely by a water turbine, which drove overhead shafts connected by leather belts to the machines. (Courtesy of Mahwah Library.)

Seven

ROADSIDE MAHWAH

The story of highway businesses, or "Roadside Mahwah," begins in the 1700s with mills. This industry was so important to local communities that millers were usually given the land upon which to establish their mills. The other essential trade was that of the blacksmith, who shod horses, made iron tools, forged hardware, and could repair almost anything.

General stores, cluttered with an amazing variety of merchandise, prospered from the mid-1800s to the early 1900s. Mahwah's population relied upon the Crouter Store on Franklin Turnpike and the John Winter and A.J. Winter and Son stores at the station. General stores declined when mail order catalogue sales and delivery by Railway Express reduced their usefulness. Mahwah's tourist businesses from the 1880s through the 1920s included the Mahwah Hotel, built in the 1860s as a railroad hotel that still exists today; the 19th century Miller Inn, formerly the Ezra Miller mansion; a subsequent Miller or Mahwah Inn; and private homes and boarding houses catering to summer boarders and tourists. Franklin Turnpike attracted a variety of commercial establishments, especially near the depot.

When Route 2 (later Route 17) was built in 1932, it rapidly attracted highway businesses. Furman's Mountain View at the intersection of Ramapo Valley Road was a typical roadside restaurant and gas station. Slightly south on Ramapo Valley Road, Smith's Grand View Lodge opened and then became Bill Brown's Grand View Lodge. Accommodations such as these, with separated cabins, were popular. Brown's is now the Mason Jar Restaurant. Pal's Diner was a landmark 1950s diner but, unfortunately, when it was put on the market in 1993, it was sold outside of Mahwah to buyers in Grand Rapids, Michigan. The new owners reopened the diner in 1996. Wassner's 24-hour super station, which became Reinauer's, now Liberty, was a modern truck stop. The Stateline Diner was built in the 1970s.

When Route 17 was made a dual highway in 1956, there was open space along the road; now, there is hardly any land left that isn't developed or set aside as wetlands.

Throughout the 1800s, the sounds of splashing water and the chunk-chunk-chunk of wooden waterwheels in Mahwah could be heard on the Ramapo River, Masonicus Brook, and Darlington Brook. These two 1895 photographs taken by Henry O. Havemeyer of the Wanamaker mill and distillery, on Island Road, document a small neighborhood mill, the type once found all across America. Above, the building close to the road is the cider mill and distillery, with the sawmill behind it. The white bridge railing is where the millpond outlet flows under Island Road. Below, the sawmill is seen, with the waterwheel housing, the millpond, and the dam to the right. All that remains of the mill today is a portion of the tailrace stonework. (Both courtesy of Mahwah Library.)

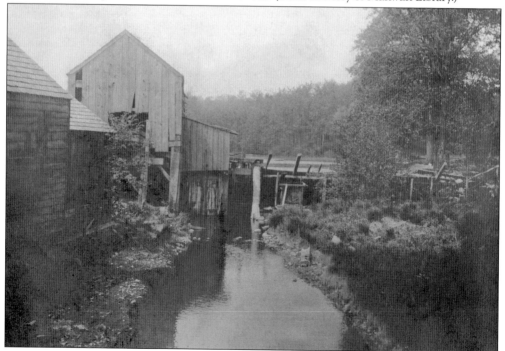

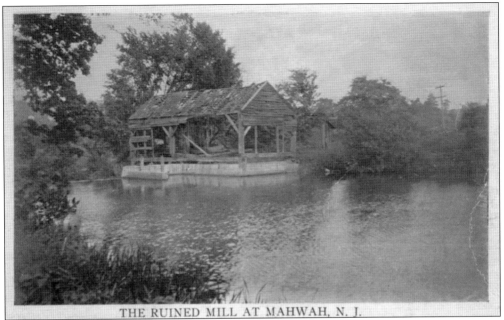

THE RUINED MILL AT MAHWAH, N. J.

The Wanamaker cider mill lasted into the 1910s, when all the buildings fell into disuse and ruin. The millpond was developed into Sunset Recreational Lake in the 1930s. (Courtesy of Gene McMannis.)

This 1861 G.M. Hopkins wall map shows businesses in Mahwah. On Franklin Turnpike (right of center), there is a blacksmith ("B.S.") and a wagon shop ("Waggon Sh."). Farther down is the Crouter store. On Island Road (left of center), there is another blacksmith shop ("B.S.S.") and the Wanamaker sawmill and distillery. Three additional stores and three more mills are noted. (Courtesy of Marion Brown.)

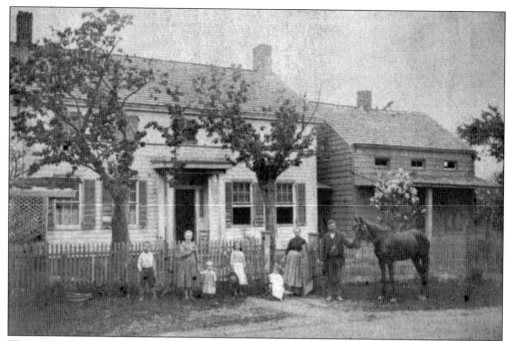

This 1891 photograph of the Crouter-Garrabrant homestead shows the original Crouter store, established in the 1850s, on the right, and the Garrabrant family house, which still stands, on the left. Garry Garrabrant and Jennie Crouter Garrabrant (right) pose in front of the house with their children, including Hattie, who sold hot dogs, ice cream, fruits, and vegetables from the homestead as a young woman. (Courtesy of Jeanne Hildebrandt.)

This 1858 invoice is for purchases from the Crouter store. It reads, "Hohokus New Jersey Mr Richard Christie bought From James Crouter Two shuvels at $1.75 2 #20 Rope 0.31 2.06 Received payment for the Above by Mr. John A. Winter June 25, 1858." It is signed, "James Crouter." (Courtesy of Ramapo Reformed Church.)

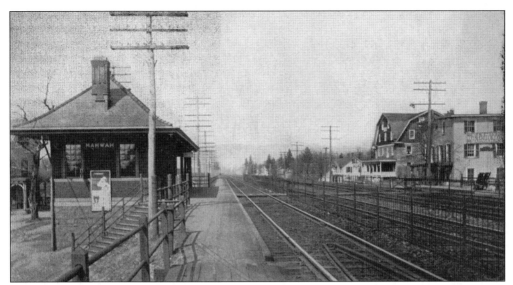

This postcard from around 1910 looks north towards Suffern, showing Mahwah's 1904 train station. Visitors took the wood-plank pedestrian walkway across four sets of tracks to get to the Mahwah Hotel and the former John Winter grocery store (with advertising on the side wall). The Winter store is gone, but the hotel still stands today. This station burned in 1914. (Courtesy of Mahwah Museum.)

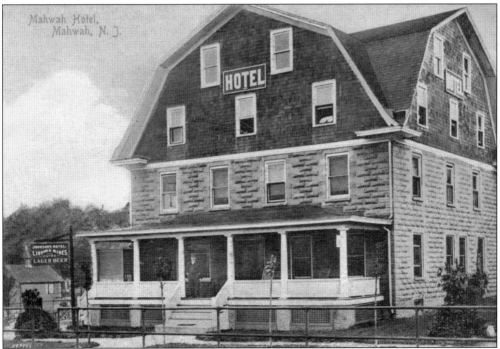

The Mahwah Hotel, built by Andrew Hagerman around 1865, housed Mahwah's first post office in 1870. Hagerman was the first postmaster and was succeeded by his son Henry B. Hagerman, who was postmaster from 1881 to 1914. This photograph is from the Johnson ownership of the hotel, from 1904 to 1911, which promoted a faithful bar trade. The building became a rooming house in the 1920s, a use that continues today. Although it has been remodeled, it is Mahwah's first and only early railroad hotel. (Courtesy of Gene McMannis.)

The G. Hopper Van Horn general store, established in 1875, was purchased by A.J. Winter & Son in 1880 and then by J.H. Dederick, who ran it from 1907 to 1914. The Hohokus Township government leased space there from 1908 to 1915, and in 1900 Mahwah's first public telephone was installed. After the building became obsolete, it was demolished in the 1950s and replaced by the parking lot east of the Old Station Museum. (Courtesy of Mahwah Library.)

Scott Widdicomb, a real estate developer from Rockland County, New York, takes a drive through Mahwah in 1910 in his fine automobile, perhaps a Chalmers, which bore the New York state courtesy plate No. 019. He is looking toward the train station (to the right, not shown). The former Winter general store, then operated by J.H. Dederick, is behind him. (Courtesy of Craig Long.)

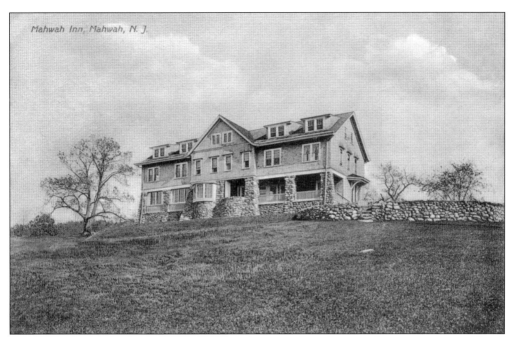

Mahwah Inn, Mahwah, N. J.

The Mahwah Inn, built in 1904, replaced Col. Ezra Miller's Oweno, the mansion-turned-hotel that was destroyed by fire. With its commanding view of the depot area, it was successful until 1927, when it, too, succumbed to fire. (Courtesy of Mahwah Museum.)

This postcard was mailed on July 21, 1911, at the peak of Mahwah's summer boarding and tourism season. One boardinghouse had 30 rooms, and many local families took in boarders. The railroad facilitated summer tourism, with families staying all week and the husband commuting on the weekend. The message on this card reads, "Have been here three days. Having a fine time!" (Courtesy of Gene McMannis.)

After the Winter homestead (above) on Franklin Turnpike was sold, it became Galli's Inn and Tea Room (below). Rachael "Ratie" Winter lamented the fact that chicken dinners were being served to strangers in her father's dining room. In 1921, at age 63, she poured out her heart in a poem called "Home," writing, "We regret that the 'Home' resurrected seems no longer a place to abide / Hereafter, the sign 'Chicken Dinner' may catch the eye of passers-by / An ache in the heart for those who look for 'Uncle John's,' our house / The dear old Home as it was." Galli's Inn became Doyle's Tavern in the mid-1940s, and, later, Pelzer's Tavern. It went on to become the Mahwah landmark Nobody's Inn. It is now Roxanne's Pizzeria. (Above, courtesy of Mahwah Museum; below, courtesy of Mahwah Library.)

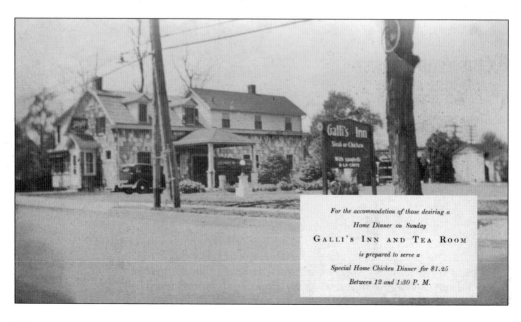

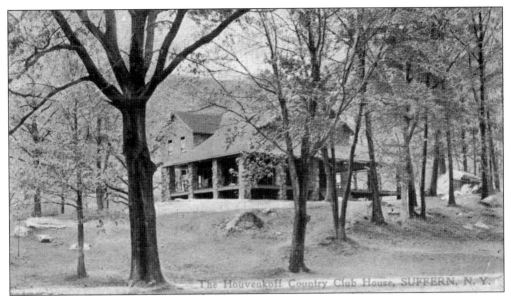

The exclusive Houvenkopf Country Club, established in 1905, struggled to survive through two wars and the Great Depression, finally declaring bankruptcy in 1945. It was reorganized as the Out O' Bounds Golf and Country Club in 1946, but that lasted only a few years. Eventually, the land became part of the Ford plant, which opened in 1955. (Courtesy of Mahwah Museum.)

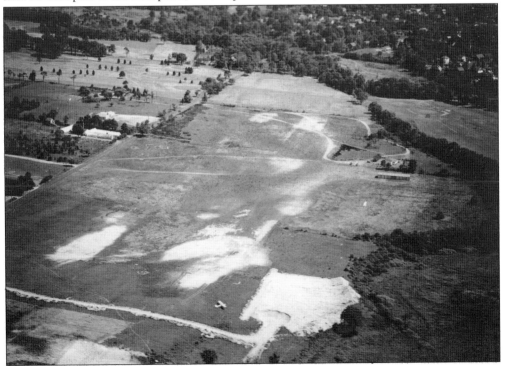

In 1946, Mahwah resident and pilot Fred L. Wehran developed Ramapo Valley Air Park, a private airport, next to the Out O' Bounds Golf and Country Club. Note the Piper Cub at bottom center. Out O' Bounds is in the upper left, Suffern is in the upper right, and Route 17 is just off the bottom. Ford acquired both properties for its Mahwah plant. (Courtesy of the author.)

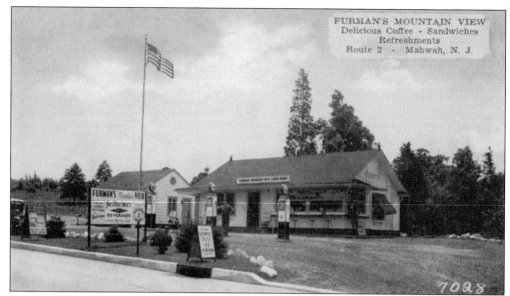

Furman's Mountain View was on the southeast side of the intersection of Route 2 (now Route 17) and Ramapo Valley Road. Note the outside luncheon counter. Improved automobiles and road conditions led to the rise in roadside facilities specifically geared toward attracting travelers by offering gas, food, and lodging. This site later became a Gulf station and a McDonald's. (Courtesy of Gene McMannis.)

Northbound traffic is seen here in the late 1930s from Furman's Esso filling station on Route 2 South. These cars were potential customers for gas and oil at the station, located at the new highway bridge over Route 202 and the Ramapo River. The shield sticker on the lower part of the pump denotes the patented "ethyl" lead additive in the premium gasoline needed for the higher-compression engines of the day. (Courtesy of Mahwah Museum.)

The 1930s cars in this photograph, taken from Furman's Mountain View, are probably coming from New York City and headed for the cool temperatures of the New York mountains. This backup would begin at the intersection of Routes 2 and 59, several miles north, and often extended as far south as the former Ramsey traffic circle. It still happens today, 70 years later. (Courtesy of Mahwah Museum.)

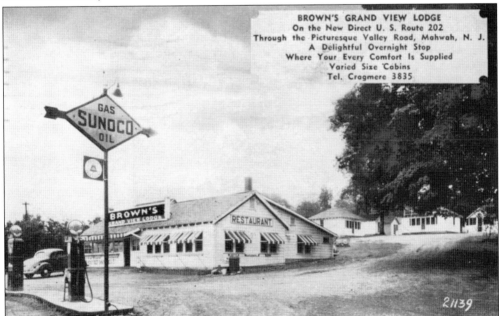

Brown's Grand View Lodge offered individual cabins, gasoline, and a restaurant to travelers along the new and improved roads. Brown's, formerly Smith's Grand View Lodge, was on Ramapo Valley Road, just south of the ramp to Route 2 (now Route 17). It is now the site of the Mason Jar Restaurant. (Courtesy of Gene McMannis.)

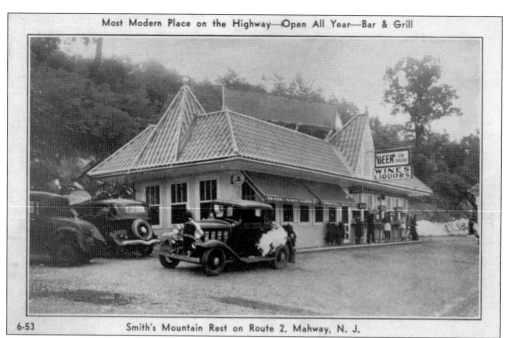

6-53 Smith's Mountain Rest on Route 2, Mahway, N. J.

Located along the southbound lane of Route 2 (now Route 17) between the New York state line and Ramapo Valley Road, Smith's was one of a string of rest stop bars catering to travelers. This mid-1930s postcard erroneously spells Mahwah as "Mahway." (Courtesy of Gene McMannis.)

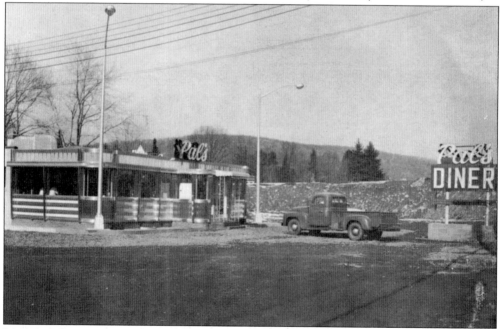

In 1954, Johnny De Zurney, a World War II veteran, purchased a silver-sided railroad dining car from the Manno Dining Car Company and opened Pal's Diner. In 1974, due to family illness, he sold the diner to George Vardoulakis. A collector's gem, the diner was sold again in 1993 to a Michigan couple who reopened it in Grand Rapids, Michigan, in 1996. (Courtesy of Gene McMannis.)

100

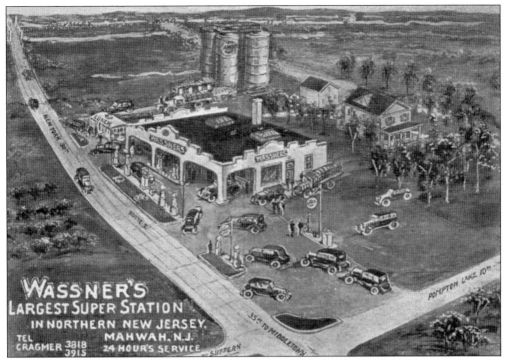

In the 1930s, Wassner's Super Station served many needs, including gasoline for cars and trucks, food, home heating oil, and mechanical repairs. The old road across the Ramapo River is seen behind the oil tanks, with the new Route 2 bridge in the upper left. The vacant land behind the station was owned by Hudson Transit Lines but was never developed as a terminal. (Courtesy of Gene McMannis.)

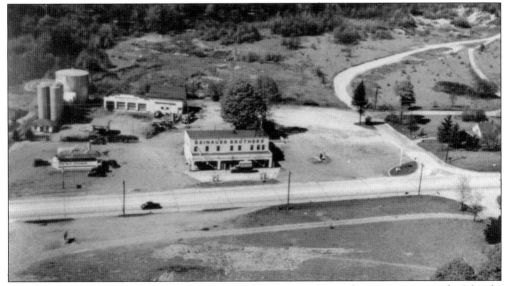

Reinauer Brothers Oil Company, which succeeded Wassner's, featured twin stations, trucker's bunks and showers, Pete's Diner, and a full-service heavy truck repair shop. Route 2 (now Route 17) is seen here when it was a dangerous three-lane highway, before it was made into dual roads in 1956. There were also no streetlights at the intersection of Stag Hill Road. (Courtesy of the author.)

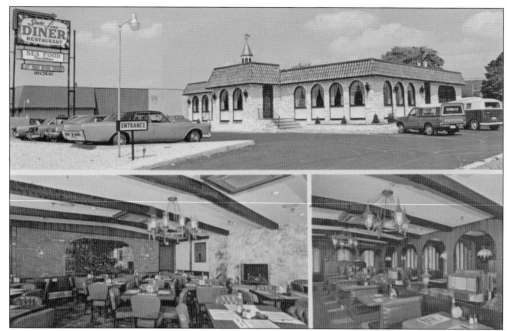

When the Stateline Diner opened on Route 17 in the 1970s, it characterized the changing landscape of Mahwah. Just south of it was a large former cow barn utilized as Farmer's Auto & Equipment Exchange. The cars in this postcard exemplify the long, exaggerated size of American cars in the 1970s. While older generations reminisce about Pal's Diner, younger generations enjoy Stateline. (Courtesy of Gene McMannis.)

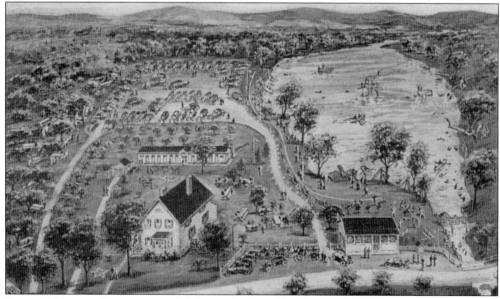

Sunset Lake, a popular recreational club, was developed by Hugo Wehmann in the 1930s on the site of the old Wanamaker millpond on Island Road, near Airmount Road. The construction of Route 2 reduced the property size, but it survived until the three-lane road was turned into a dualized highway in 1956, which took most of the pond and rear buildings. The remainder of the pond was eventually filled in and developed as highway frontage land. (Courtesy of Gene McMannis.)

Eight

FIRST RESPONDERS THROUGH THE DECADES

In the early 1900s, local constables and the county sheriff kept the peace in Mahwah. Edward Shuart was the first appointed constable. He was succeeded by Raymond Dator in 1921. The earliest police vehicle was a 1925 Indian Big Chief motorcycle. The township created an official police department in 1929, with Charles Smith as chief. The police department acquired its first Chevrolet squad car in 1933.

In 1957, the township purchased a 10-room house on Franklin Turnpike adjacent to the library and the firehouse. It became the Charles Feldmann Municipal Building, and the police headquarters were on the second floor. Edward Wickham, who was hired in 1937, rose to chief in 1960, followed by William Russo in 1970. The present police headquarters, on Franklin Turnpike, opened in 1973. Samuel Alderisio was named chief in 1985, and James Batelli in 2001.

As the township has grown, so has the Mahwah Police Department, not only in numbers (there are now over 55 officers), but also in expanded areas of training, community relations, and excellence of performance.

In 1914, Fire Company No. 1, an independent Mahwah firefighting organization, was founded with 25 charter members. Millard Cooper, the chief, utilized his own garage as the engine house. In 1918, the township created the Mahwah Fire Department, and, in 1929, built the firehouse on Miller Road, which was used for Company No. 1 as well as for municipal offices and police headquarters.

West Mahwah Company No. 2 was organized as an independent company in 1928 and became a township department in 1934. Masonicus Company No. 3 was independent from 1947 until 1956, at which time the township granted them the use of the 1852 Masonicus Schoolhouse as a firehouse. Fardale Company No. 4, independently organized in 1944, merged with the township department in 1970. In 1961, the newest fire company, No. 5, was established on Stag Hill Road and occupied the unused Mountain (Lincoln) Schoolhouse. It was replaced with a new building in 1978. Due to the elevation of the mountain, water storage for pressure and volume has been critical to the area's protection.

Both Company No. 1 and Company No. 4 expanded to provide emergency ambulance service, both of which eventually became independent emergency medical services departments.

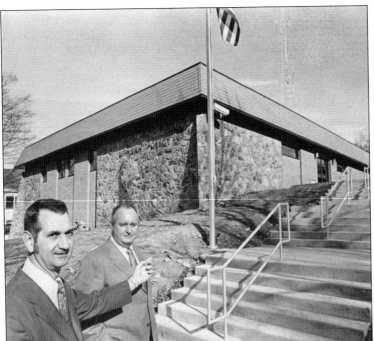

Mahwah police chief William Russo points the way to the front entrance of the new police complex completed in December 1974. The building was a vast improvement over the previous police department location, on the second floor of the Feldmann Municipal Building, where desks were in the hallway and detainees were sometimes handcuffed to plumbing pipes. (Courtesy of Mahwah Police Department.)

The highly decorated Mahwah Police Honor Guard leads a patriotic St. Patrick's Day parade in Rockland County on March 21, 2004. The guard has won many competitions for its accuracy and presentation. (Courtesy of Mahwah Police Department.)

Wearing Class A uniforms, the Mahwah Police Department poses on Memorial Day at the Feldmann Municipal Building in 1962. Mayor Morris Ruddick is in a suit third from right in the first row, future chief William Russo is on the far left of the third row, and then-chief Edward Wickham towers over the others in the center of the first row. (Courtesy of Mahwah Fire Department.)

A new 1980s Ford Mahwah police cruiser is proudly displayed in front of the Sheraton International Crossroads Hotel. In 1925, Mahwah purchased an Indian Big Chief motorcycle to address the growing mobility of the community; its first official police car was a 1933 Chevrolet roadster. (Courtesy of Mahwah Police Department.)

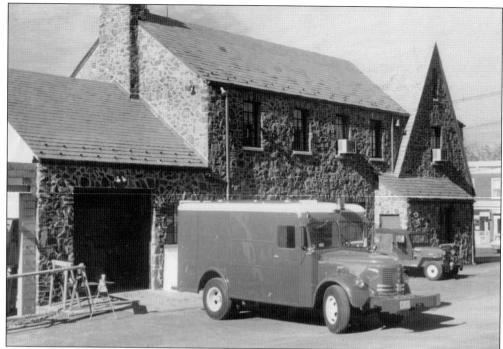

An Air Force–surplus REO Comet crash-and-rescue truck is seen here at its new home, Mahwah Fire Department Company No. 1. It was assigned to the Mahwah Ambulance and Rescue Squad as part of the Civilian Defense Program in the 1950s. Side locker compartments were fitted with all manner of rescue gear. Note the firehouse addition under construction to the left. (Courtesy of Mahwah Fire Department.)

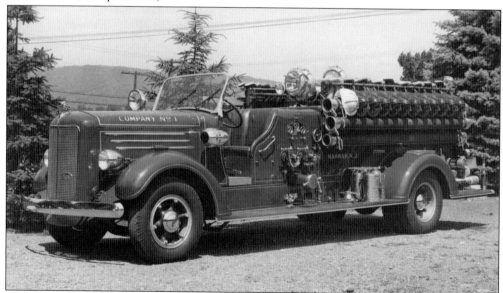

The pride of Company No. 1, this 1939 Mack pumper was ready to boost water pressure from hydrants or draft and pump water from ponds. This vehicle is from the photogenic days of fearless firefighters hanging from handrails while standing on the running boards as they raced to the fire. (Courtesy of Mahwah Fire Department.)

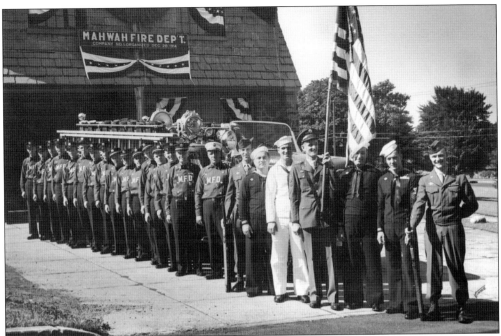

Mahwah Veterans of Foreign Wars (VFW) Post No. 7124 has served the township for over 60 years, leading parades, honoring fallen heroes, and maintaining a brotherhood among veterans. Here, VFW members form the flag honor guard along with Fire Company No. 1 on Miller Road. The company's 1939 Mack pumper is in the background. (Courtesy of Mahwah Fire Department.)

This rare photograph shows the Mahwah Home Guard during World War II. The various home guards eventually became the New Jersey National Guard. Many of these men were Ukrainian and Polish immigrants who worked for the American Brake Shoe Company and volunteered to defend their adopted country. (Courtesy of Mahwah Library.)

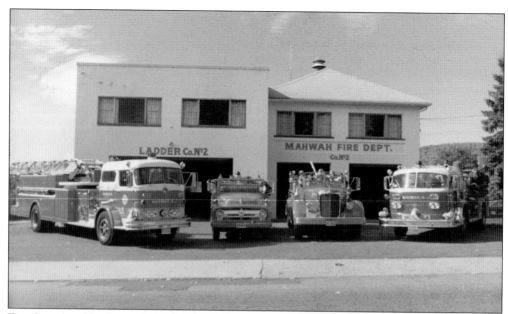

Fire Company No. 2 was formed independently in 1928 to protect the growing development of workers' homes west of the railroad and the American Brake Shoe factory itself. The low railroad bridges had restricted the use of large engines and reduced response time in either direction. (Courtesy of Mahwah Fire Department.)

Members of Fire Company No. 2 are seen here at the Immaculate Heart of Mary Roman Catholic Church on Island Road leaving an annual prayer service commemorating those members who have passed on. The church was built in 1916, and has since been replaced by a new building. (Courtesy of Mahwah Fire Department.)

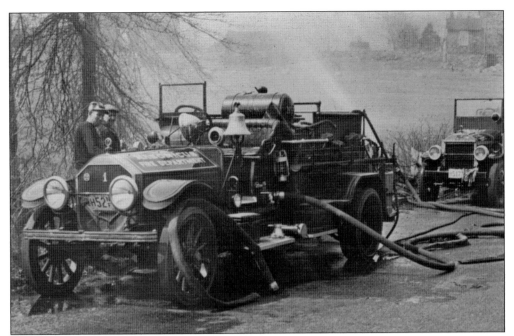

Independent Masonicus Company No. 3 pumper trucks are seen here at a fall brush fire in 1947. This venerable piece of firefighting apparatus dates from the 1920s, and had already given 15 to 20 years of service elsewhere before arriving in Mahwah. Note the hand-cranked siren, the bell, the right-hand steering wheel, and the windscreen for only the driver. Engine water temperature was shown in the Moto Meter atop the radiator. (Courtesy of Mahwah Museum.)

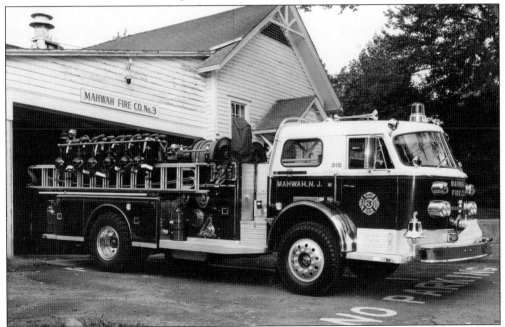

Mahwah Fire Department Company No. 3's engine/pumper was displayed in front of its home, in the addition to the former Masonicus one-room schoolhouse. Company No. 3 now has modern facilities behind this building. (Courtesy of Mahwah Museum.)

Independent Masonicus Fire Company No. 3's first firehouse, on Crescent Avenue, a slightly oversized garage big enough for one truck, is typical of the humble beginnings of Mahwah's early fire companies. The independent company of volunteers, mostly farmers, provided their own equipment and borrowed this building for their rig. (Courtesy of Mahwah Museum.)

After acquiring the 1852 schoolhouse, Company No. 3 added the engine bays and used the former one-room schoolhouse for meetings, training, and equipment maintenance. This old building has served the area's academic, protective, and spiritual needs, as a school, church, firehouse, and again as a church, for over 160 years. (Courtesy of Mahwah Museum.)

Mahwah Fire Department Company No. 5 occupies a modern structure built in 1978 that provides protection on the mountain. Company No. 5's first home was the old Mountain (Lincoln) School. Prior to its formation in 1961, this area of the township relied upon the far-away Company No. 2, and the long response time resulted in several total losses of buildings. (Courtesy of Mahwah Fire Department.)

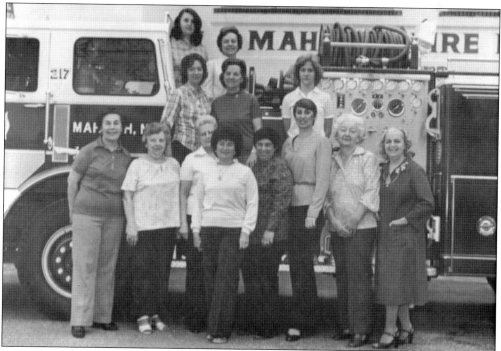

No fire department is complete and fully functional without its women's auxiliary. Here, members gather in front of Company No. 2's engine No. 217. Even the mayor's wife, Adrienne Kent (first row, far right), served on it. When the ambulance corps were formed, the women of the auxiliary found new, more active ways to serve their neighbors, as drivers and paramedics. (Courtesy of Mahwah Fire Department.)

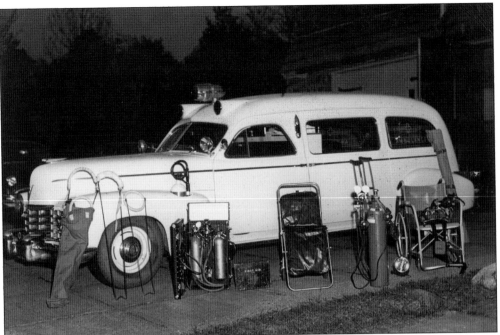

Mahwah's first ambulance is seen here fully equipped with a Fire Company No. 1 display of Ambulance Corps equipment. The 1947 Cadillac rig was as up-to-date as anything at the time. It served as the township's only ambulance for decades, until Company No. 4 formed Mahwah Ambulance Company No. 4 in 1971. (Courtesy of Mahwah Fire Department.)

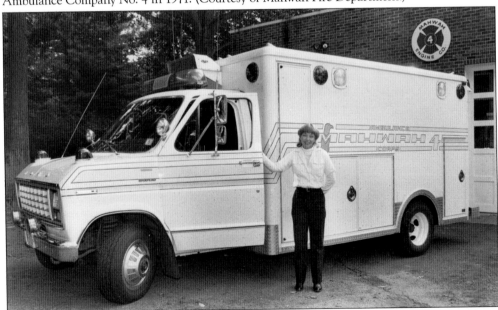

This Mahwah Ambulance Corps No. 4 "box rig" replaced the early 1950s Cadillac that had been purchased used from a South Bergen County ambulance squad. State requirements called for rigs with multiple litters and more extensive first aid equipment, as well as more intensive training to increase the skills of paramedic first responders. Note the "Mahwah Engine Co. 4" logo on the firehouse in the background. (Courtesy of Mahwah Fire Department.)

Nine

UNUSUAL HOUSES

In early America, commercial activities were often carried on in one's house. For instance, a "store house" served as both a place of business and a dwelling. There were also courthouses, meeting houses, houses of worship, school houses, dwelling houses, carriage houses, jail houses, spring houses, green houses, and, of course, outhouses.

The large, rambling general store adjacent to the Mahwah depot was a typical store house. From 1890 to 1907, when the first-floor store was run by A.J. Winter and his son, Albert, the family lived on the second floor. By the early 1900s, general stores and store houses had begun to wane as main street shopping and department stores became available.

Icehouses bear special mention. Harvesting ice was one of the more common industries in the country. With plows, saws, hooks, and chisels, ice harvesters marked pond ice into blocks, cut it, floated it to shore, and then pulled the blocks by horses or men up a steep wooden slide into the icehouse. Some ice houses were so gigantic that clouds formed in the space above the ice. Buildings were of rough boards with double walls. Blocks of ice were separated by layers of sawdust. With the advent of electric refrigeration, ice was no longer needed. The oversized buildings were unsuited for other purposes and within a decade, all traces of this industry vanished.

Small, ancillary buildings at farms are charming, but usually torn down when they are no longer needed. Stone spring houses nestled low against hills and cooled by a spring kept milk and other food cool. There were also smokehouses, piggeries, henneries, and chicken houses, corn cribs, manure houses, tack houses, etc.

In the 1800s, Mahwah had seven one-room schoolhouses. Four still exist, reminding locals of the charming days of eight grades in one room, warmed by a potbelly stove in winter, and taught by one teacher. This was the system for over a century until Mahwah's first four-room schoolhouse, the Mahwah School (later called Commodore Perry School), was built in 1906.

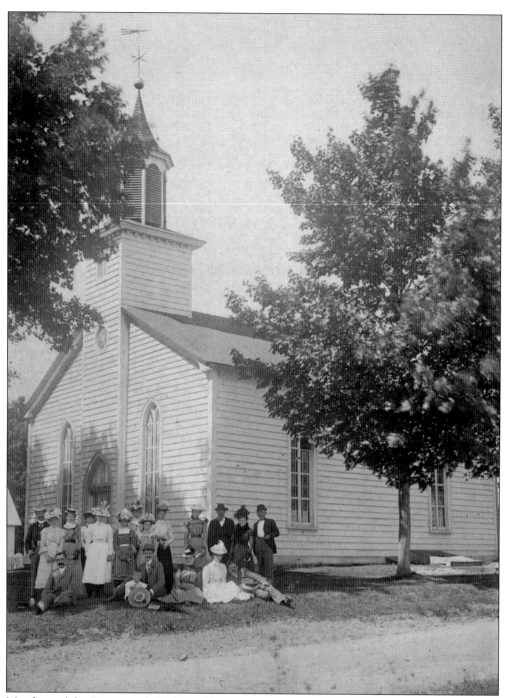

Members of the Ramapough Meeting House, now the Ramapo Reformed Church, pose for the camera on a balmy day in 1904. The church was organized in 1785 and built in 1798. It is the oldest Federal-period, wood-frame church remaining in Bergen County, and is listed in the National Register of Historic Places. In Colonial America, many Protestant churches were called meeting houses. (Courtesy of Ramapo Reformed Church.)

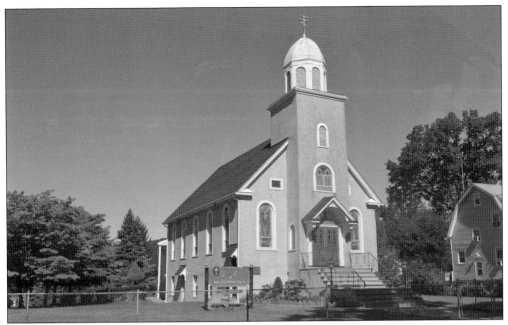

The Holy Spirit Catholic Church (Byzantine Rite), on Island Road, was built in 1929 to serve the Eastern European residents of West Mahwah. There are two such Catholic churches in this neighborhood. The other, the Immaculate Heart of Mary Roman Catholic Church, was originally built in 1916, and the congregation recently constructed a new church. (Courtesy of Lindsey Barrett.)

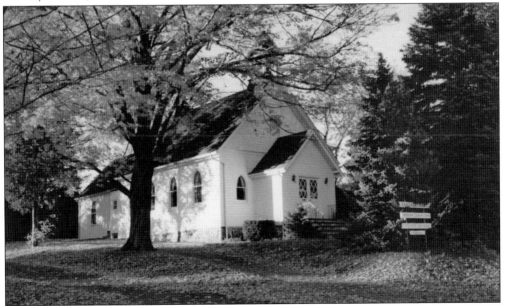

Residents of the Fardale section of Mahwah organized a nonsectarian congregation in 1874 that became the Campgaw Union Sunday School Association in 1896. The Fardale Chapel, seen here, was built in 1897. The Hohokus Township Board of Education built a one-room schoolhouse for the children of Fardale in 1909, which held about 30 students. The Redeemer Cemetery is adjacent to the chapel. (Courtesy of Richard Greene.)

The Immaculate Conception parish church was established when the Immaculate Conception Seminary opened in Darlington in the 1920s. The church is seen above when the trees that still line its sidewalk were young and small. Angela Wozniak Karpowich (above, right), a member of the Roman Catholic church in West Mahwah, is seen ready to receive first communion. There were three Catholic churches in Mahwah in the early 1900s. (Both courtesy of Mahwah Museum.)

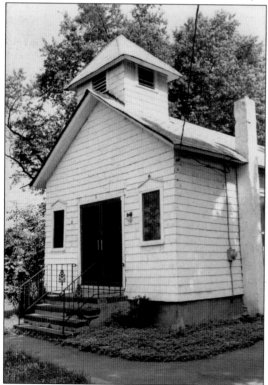

When the new Darlington Schoolhouse was built in 1891, the old schoolhouse was given to the Green Mountain Valley settlers, who moved it to the mountains. The settlement disbanded in the early 1900s, and the church was moved to Grove Street, where it is now the African Methodist Episcopal Church. A small congregation has kept the church alive for 150 years. (Courtesy of Mahwah Museum.)

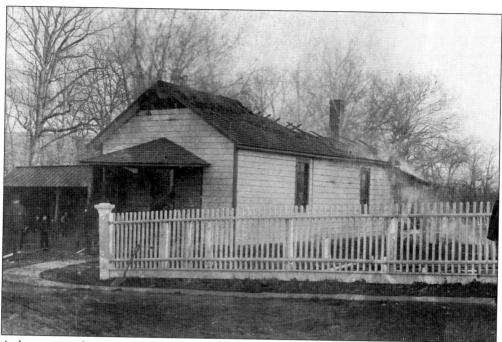

A devastating fire consumes the roof of the chapel-lecture building of the Ramapo Reformed Church, which burned to the ground in 1895. The building was formerly used as the community's first schoolhouse, around 1815. Note the shovel leaning against the picket fence, and the horse sheds to the left of the building. (Courtesy of Mahwah Museum.)

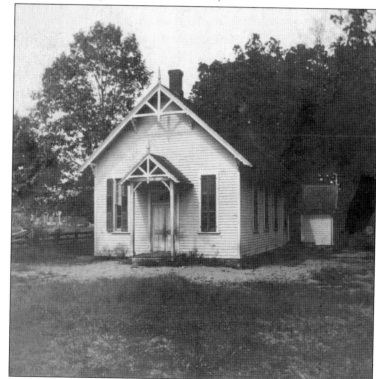

A schoolhouse was built in the Masonicus section of Mahwah in 1820, and then rebuilt in 1852 across the street. This tenacious little building has been a schoolhouse, a church, a firehouse, and now a church again. (Courtesy of Mahwah Museum.)

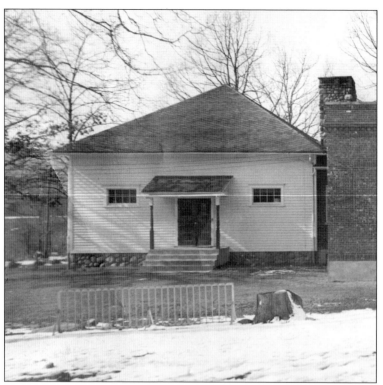

About 1910, a small frame schoolhouse was built in the Fardale section of Mahwah on the north side of Fardale Avenue. A brick building was added onto it. In the mid-1950s, the frame building was moved to the south side of the street, and the present firehouse was built around it. A new school was built in the original location and named the George Washington School. (Courtesy of Mahwah Museum.)

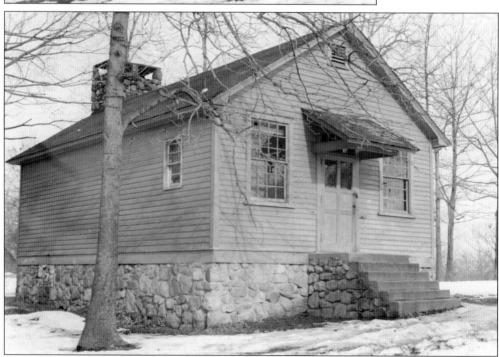

The Mountain School, or Abraham Lincoln School, served the children in the Stag Hill community until 1945, when the board of education closed it down. It was demolished in the 1980s. (Courtesy of William Trusewicz.)

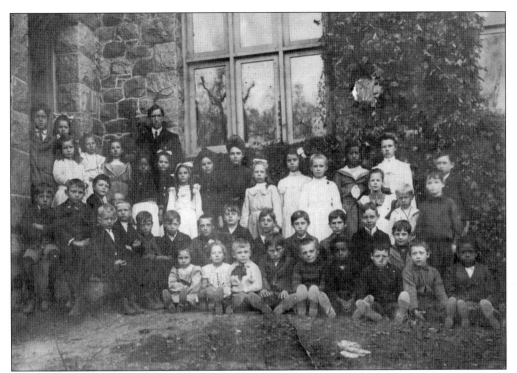

The 1905 class at the one-room Darlington Schoolhouse, on Ramapo Valley Road, is seen here. At this time, there were 42 pupils of all ages in a single class, taught by one teacher, Isaac Serven. The Darlington Schoolhouse, for all its Gilded Age glamour, was still a traditional one-room schoolhouse. (Courtesy of Mahwah Museum.)

The musical ballet *Hansel and Gretel* is performed in 1949 by the Mahwah Girl Scouts at the Darlington Schoolhouse, on the stage in the second-floor hall. Yvonne Dator taught ballet at the schoolhouse from the late 1940s to the 1960s. (Courtesy of Susan Schneider Sampson.)

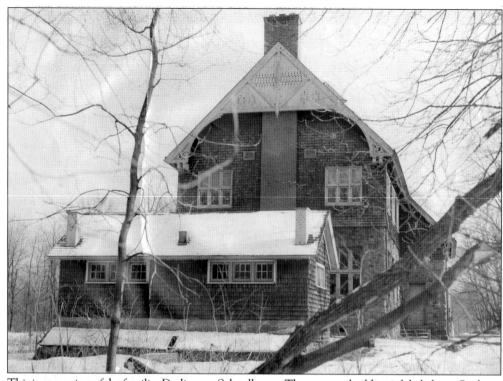

This is a rear view of the familiar Darlington Schoolhouse. The separate building is labeled on a Sanborn Insurance map as "WC," meaning water closet, or restroom. (Courtesy of Mahwah Museum.)

Isabel Hudson taught a class of students in grades one through four at the Darlington Schoolhouse in 1940, when it was still under the jurisdiction of the Mahwah Board of Education. She snapped this photograph of her pupils lined up at the water pump at the back of the building, waiting for a drink of clear spring water. Soon after, the board of education closed the school. (Courtesy of Mahwah Museum.)

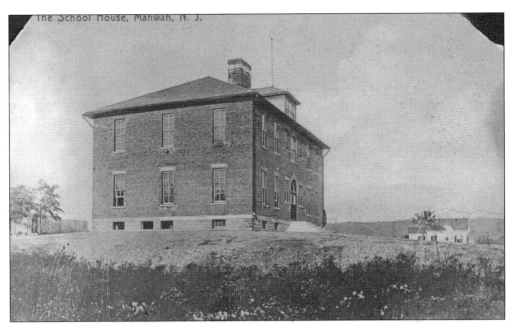

The Mahwah School was Mahwah's first four-room schoolhouse, built in 1906. In 1945, the school was renamed the Commodore Perry School. Numerous additions were built over the years to accommodate a steady increase in the student population. (Courtesy of Mahwah Museum.)

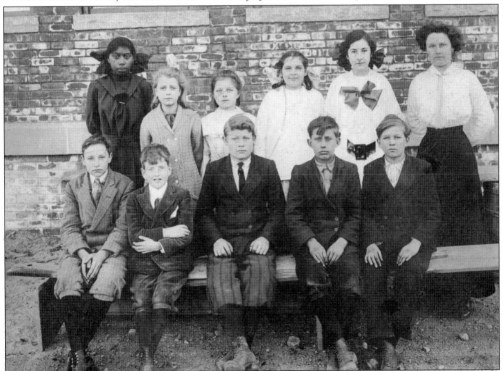

This is a small class at the Mahwah (Commodore Perry) School in 1910. The children are dressed up for their school picture; the boys in jackets and ties and the girls in dresses and hair bows. (Courtesy of Mahwah Museum.)

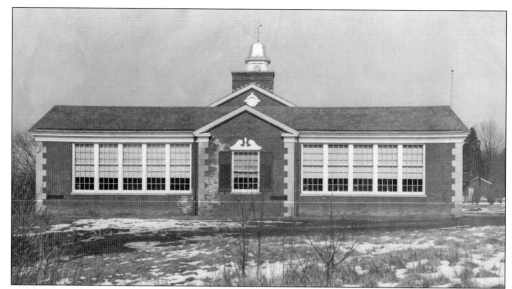

Betsy Ross School, built in 1932, was the first public school built after the 1906 Commodore Perry School. There was considerable impetus in town to build more schools, but many voters feared taxation, and the township committee was cautious. Eventually, after a lot of "growing pains," the decision to build more schools became unanimous. (Courtesy of Mahwah Museum.)

This 1952 photograph at Betsy Ross School shows children being taught in an up-to-date schoolroom. The days of the one-room schoolhouse were long gone. The school has been expanded several times and is still in use today. (Courtesy of Susan Schneider Sampson.)

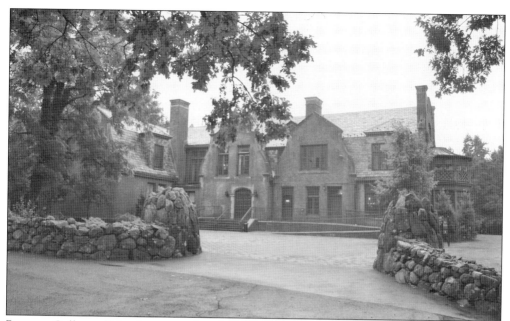

Ramapo College of New Jersey was founded in 1970 and built on a 340-acre estate on Ramapo Valley Road. The college's curricular emphasis includes liberal arts and sciences, social sciences, fine and performing arts, and professional programs. The Birch mansion (above), built between 1887 and 1890 by Theodore Havemeyer, was sold to Steven Birch Sr. in 1917 and now houses the college's administrative offices. McBride House (below) was built in 1890 as a guesthouse for Havemeyer visitors. It is currently the office of enrollment management. Ramapo College has been a significant force for historic preservation in Mahwah, having preserved and adaptively reused the Havemeyer mansion (the college president's home), the Birch mansion, the guest cottage, and the Havemeyer arch, which is now the college's logo. (Both courtesy of Lindsey Barrett.)

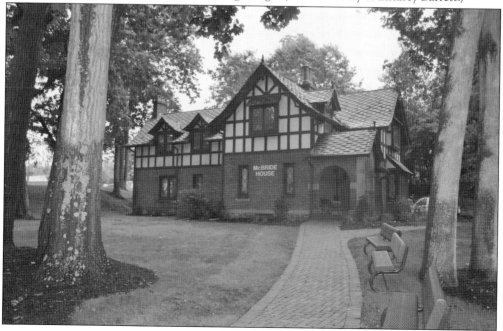

The building in the background of this photograph is Garret G. Ackerman's icehouse, which was under construction on Ackerman Pond in Mahwah. The photograph was taken on the Mahwah–Franklin Lakes border. While the icehouse is in Mahwah, the boaters are in Franklin Lakes. John Storms, Ackerman's son-in-law, developed an ice route. (Courtesy of Thomas and Jo Heflin.)

This is the loading incline of the Havemeyers' Mountain Side Farm icehouse (following page). After the blocks of ice were cut, they were loaded into the icehouse by horses and pulleys or by men pulling them up this incline. It was an arduous task. (Courtesy of Mahwah Library.)

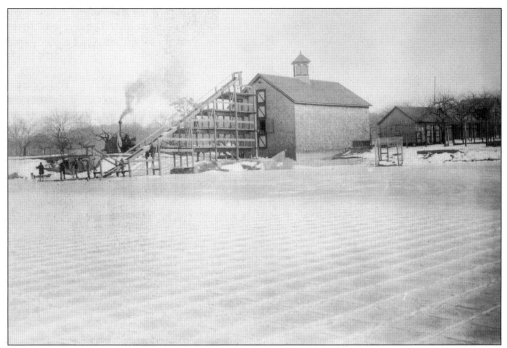

The icehouse at Mountain Side Farm (above) was positioned on the shore of what was later named Lake Henry. Imagine the process of loading ice into this icehouse by pulling it up the incline. The ice on the lake is marked for cutting. Mountain Side Farm's large cow barn, which could house 500 cows, is in the background below. (Both courtesy of Mahwah Library.)

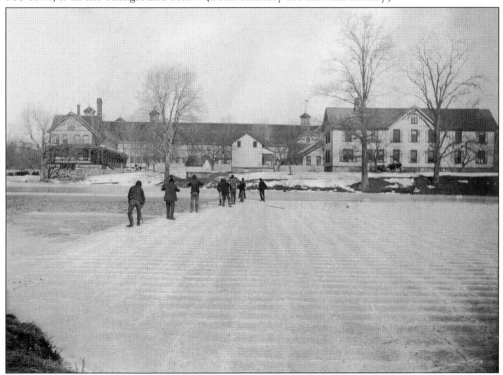

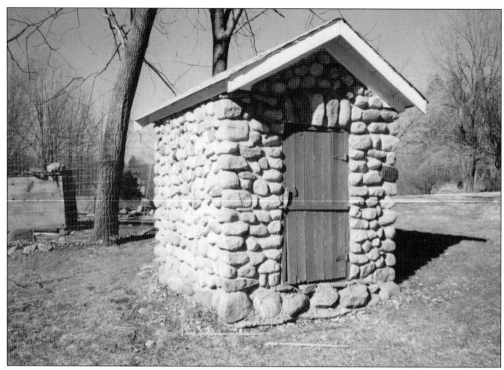

This fieldstone smokehouse (above) and piggery (below) still stand today on the Bartholf–Van Voorhis farm property in Fardale. The buildings show how farmers made use of the endless supply of fieldstones dug up during the clearing of the fields. (Both courtesy of Richard Greene.)

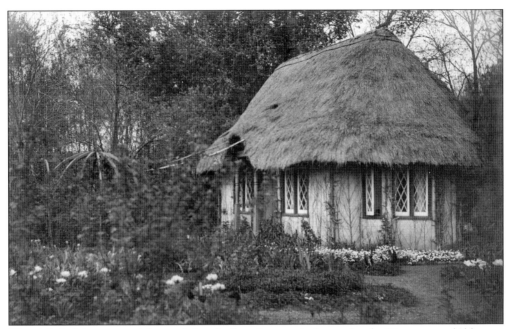

This delightful cottage with a real thatched roof was a playhouse for the Havemeyer children at Mountain Side Farm. However, it was not the first thatched roof in Mahwah. In 1813, traveler Gerry Elbridge Jr. described beautiful and interesting sights of the Ramapo Valley, including "barns and other buildings covered with thatch." (Courtesy of Mahwah Library.)

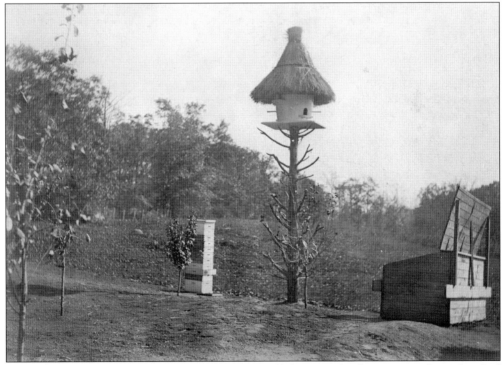

This unique birdhouse at Mountain Side Farm wins all the prizes for charm. It, too, has a thatched roof, likely made of reeds gathered in the nearby wetlands. (Courtesy of Mahwah Library.)

DISCOVER THOUSANDS OF LOCAL HISTORY BOOKS
FEATURING MILLIONS OF VINTAGE IMAGES

Arcadia Publishing, the leading local history publisher in the United States, is committed to making history accessible and meaningful through publishing books that celebrate and preserve the heritage of America's people and places.

Find more books like this at
www.arcadiapublishing.com

Search for your hometown history, your old stomping grounds, and even your favorite sports team.